IMAGES
of Rail

NILES CANYON
RAILWAYS

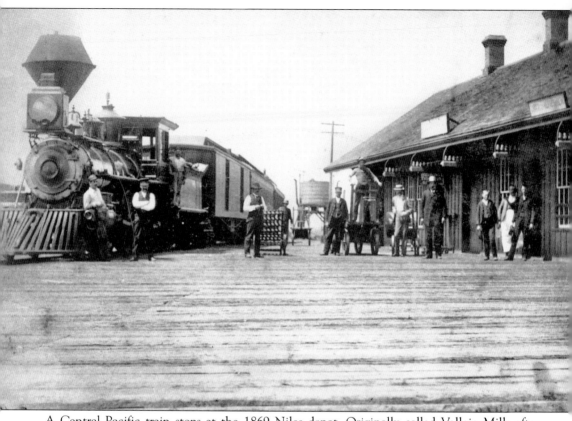

A Central Pacific train stops at the 1869 Niles depot. Originally called Vallejo Mills after General Mariano Vallejo, Niles was renamed by the railroad that same year, after Judge Addison C. Niles, a Central Pacific attorney and stockholder. Replaced by a new depot in 1901, the original building was moved to become the town's library, then moved again years later to become a private home, which it remains to this day. (Vernon Sappers Collection; courtesy of Western Railway Museum.)

IMAGES
of Rail

NILES CANYON
RAILWAYS

Henry J. Luna and
the Pacific Locomotive Association

ARCADIA
PUBLISHING

Published by Arcadia Publishing
Charleston SC, Chicago IL, Portsmouth NH, San Francisco CA

Printed in the United States of America

Library of Congress Catalog Card Number: 2005920898

For all general information contact Arcadia Publishing at:
Telephone 843-853-2070
Fax 843-853-0044
E-mail sales@arcadiapublishing.com
For customer service and orders:
Toll-Free 1-888-313-2665

Visit us on the Internet at www.arcadiapublishing.com

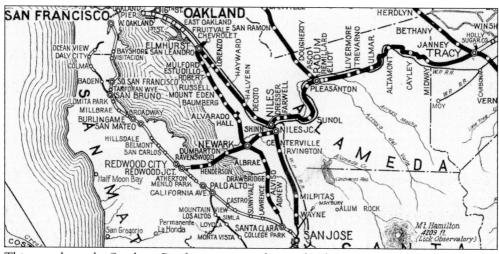

This map shows the Southern Pacific routes in and around Niles.

CONTENTS

MAPS

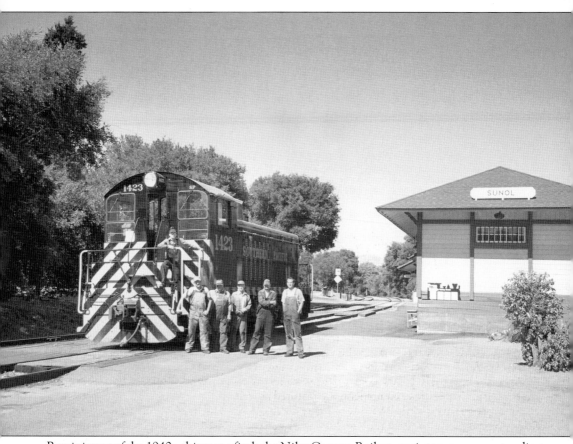

Reminiscent of the 1940s, this scene finds the Niles Canyon Railway maintenance crew standing by their 1949 Southern Pacific NW2 diesel No. 1423 at Sunol. In 1984, however, there was no diesel, no depot, and no track at this location. This nostalgic 2004 photo was made possible by the restoration efforts of the Pacific Locomotive Association. (Author's photo.)

INTRODUCTION

This is the pictorial history of the Niles Canyon Railway, plus a look at the other railroads that served Niles Canyon from the first train in 1866 to today. Both the steam and diesel years are included, with special emphasis on the Southern Pacific era. The history and accomplishments of the Pacific Locomotive Association, the volunteer group that has donated hundreds of thousands of hours and dollars to keep the rail history of Niles Canyon alive, and their efforts to preserve historical railroad equipment, are featured as well.

Our story begins in July 1853, when a team from the Benicia Arsenal initially surveyed Niles Canyon as one of three proposed railway routes to the Pacific Coast. President Abraham Lincoln chose the route through Niles Canyon and signed the Pacific Railroad Act in July of 1862, to build a rail line between the Mississippi River and "the Pacific coast, at or near San Francisco, or the navigable waters of the Sacramento river."[1]

In Sacramento, the "Big Four" as they would later be called—dry goods merchant Charles Crocker, dealers in hardware and blasting powder Collis Huntington and his partner Mark Hopkins, and grocer Leland Stanford—took on the challenge to build the Central Pacific Railroad from the Sacramento waterfront eastward over the Sierra Nevada. At the same time, the Union Pacific Railroad was extending tracks westward from Omaha to meet the Central Pacific. The two Pacific Railroads joined at Promontory, Utah, on May 10, 1869, to become America's first transcontinental rail line. This major development made the West easily accessible for the first time, with the trip to California reduced from weeks to a matter of days. However, to reach San Francisco, where the vast majority of riders were bound, passengers and freight had to be transferred to riverboats at Sacramento for the final portion of the trip.

The Western Pacific Railroad was formed and incorporated in December 1862 to build a railroad from San Jose to Sacramento. A connection at San Jose with a line to San Francisco would complete the transcontinental route, from ocean to ocean. Construction started in 1865. The following year, Western Pacific became the first railroad into Niles Canyon when their first 20-mile section of track was built from San Jose to a point in the canyon just beyond Farwell, where construction halted.

In 1868, the Central Pacific, under the guidance of Stanford, purchased the bankrupt Western Pacific, and in early 1869, started work to complete the line as an extension of their railroad. This was accomplished by building track from Sacramento to Stockton and Tracy, then over Altamont Pass, across Livermore Valley (called Amador Valley at the time), and through Niles Canyon, to connect with track to Alameda. This route, using the Western Pacific tracks in

the canyon, was completed on September 6, 1869, just four months after the driving of the Gold Spike in Utah. The terminus was changed to Oakland on November 8 of that year, when three small railroads, including the Western Pacific, were absorbed into the growing Central Pacific system. All trains running in and out of the San Francisco Bay Area passed through scenic Niles Canyon.

The California Pacific Railroad completed a shorter line from Sacramento to Vallejo, with transfers to San Francisco by ferryboat, in 1870. The Central Pacific later purchased the Cal-P, as it was called. Under the name Northern Railway, Central Pacific built a line from Suisun to Benicia. Entire trains were ferried from Benicia across the Carquinez Strait to Port Costa, where the rail line continued to Oakland. This became the transcontinental route of preference, relegating Niles Canyon to secondary status.

Central Pacific grew and, on April Fool's Day 1885, the company reorganized with Southern Pacific replacing Central Pacific as the dominate company, although the corporate name existed on the books until 1959. As a secondary route, the Niles Canyon line wasn't significantly upgraded until around the turn of the century, when the railroad came under the control of Edward H. Harriman. Some track realignments were made, new depots were built at Niles and Pleasanton, new signals were installed along with heavier rails, and steel bridges replaced the original wooden bridges.[2]

A second transcontinental railroad entered Niles Canyon in 1909. Also called the Western Pacific (but not related to the first Western Pacific), it was constructed on the southern side of Alameda Creek through the canyon. Western Pacific's ultimate claim to fame was their famous streamliner *California Zephyr*, which passed through Niles Canyon daily from 1949 until 1970. Union Pacific, the same company that met the Central Pacific at Promontory in 1869, acquired the Western Pacific in 1981, and absorbed the Southern Pacific as well, in 1996. Union Pacific freight trains and Altamont Commuter Express trains now roll through Niles Canyon, using UP's ex-Western Pacific track.

The year-round waters of Alameda Creek, combined with the natural beauty of oak-studded Niles Canyon, have attracted and delighted the public since the mid-1800s. Special trains carried weekend fun-seekers from San Francisco and Oakland to the canyon for boating, fishing, swimming at favored spots, and dancing at one of the many open-air pavilions. This lasted until the late 1920s and early 1930s, when automobiles became common and the Great Depression curtailed travel. All passenger service was discontinued in 1941.

Southern Pacific freight trains continued to run through the canyon until 1984, when the company closed the line and removed the track. Much of the property was turned over to Alameda County. It seemed that this significant part of railroad history would be lost forever. But preservation providence stepped in.

A group focused on western rail heritage, the Pacific Locomotive Association, sought a new home for their extensive collection of full-sized vintage trains. They contracted with Alameda County for use of the empty right-of-way on a long-term basis, and the Niles Canyon Railway was the result. Track, the basic necessity that had been removed by the SP, was rebuilt using rail donated by UP, with Pacific Locomotive Association volunteer members doing all the work. By 1988, trains were running once again on a one-mile portion of Mr. Lincoln's railroad. Since then, the line has been expanded to about 10 miles in length.

Niles Canyon has its own history that includes visits by a famous bandit, a tramp, and a dog. Now visitors from all over the U.S. and many foreign countries come to ride the vintage trains and enjoy the scenic beauty of Niles Canyon, which looks much the same as it did over a hundred years ago. The Niles Canyon Railway has become one of the premier operating railroad museums in America, preserving a part of our past for future generations to experience and appreciate.

[1] From "Report of the Chief Engineer on the Preliminary Survey . . . " by Theodore Judah, reprinted in *High Road to Promontory*, pp. 301-307
[2] From "Niles Canyon Master Plan" by G. Osmundson, R. Hees, et al. 2002.

One

TRAINS OF NILES CANYON

A BRIEF HISTORY

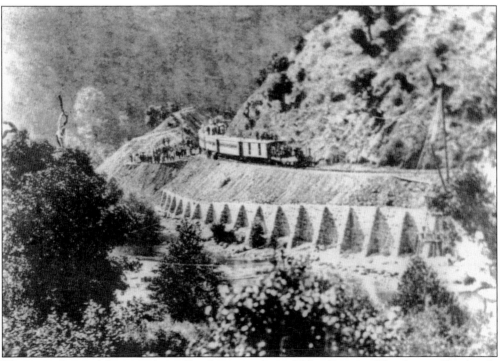

This is a photo of the very first official train to enter Niles Canyon. The date is October 2, 1866, and the location is the big curve just east of "The Spot." Western Pacific Railroad, the first company to lay tracks in the canyon earlier that year, was building a line from San Jose to Sacramento when corporate problems halted their efforts. Their train is carrying the federal Railroad Commission, whose members are inspecting the line so that the builder can receive the first-mortgage bonds and land grants. This was also the last train through the canyon for three years, as the railroad suspended operations after completing their first 20 miles. Founded in 1862, Western Pacific merged with Central Pacific in June, 1870. (Clyde Arbuckle Collection; courtesy of Randy Hees.)

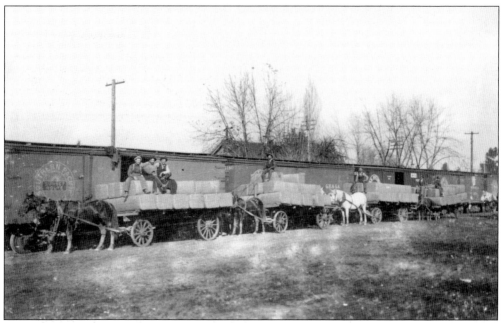

Bales of hops are being loaded into boxcars at the Pleasanton depot for shipment by rail. This became possible when Central Pacific built the railroad from Sacramento to San Jose through Niles Canyon. On September 6, 1869, the line was opened to both freight and passenger trains, completing the Transcontinental Railroad to San Francisco, just four months after the Gold Spike was driven at Promontory, Utah. (Courtesy of Amador-Livermore Valley Historical Society.)

In the mid-1880s, Niles featured a two-stall engine house with turntable and a square water tank. A westbound Central Pacific train coming through Niles Canyon would turn toward Oakland on this track, which is the north leg of the Niles wye. Trains destined for San Jose or San Francisco would use the south leg of the wye, just out of view on the left. (Mayhew Collection; courtesy of Museum of Local History, Fremont.)

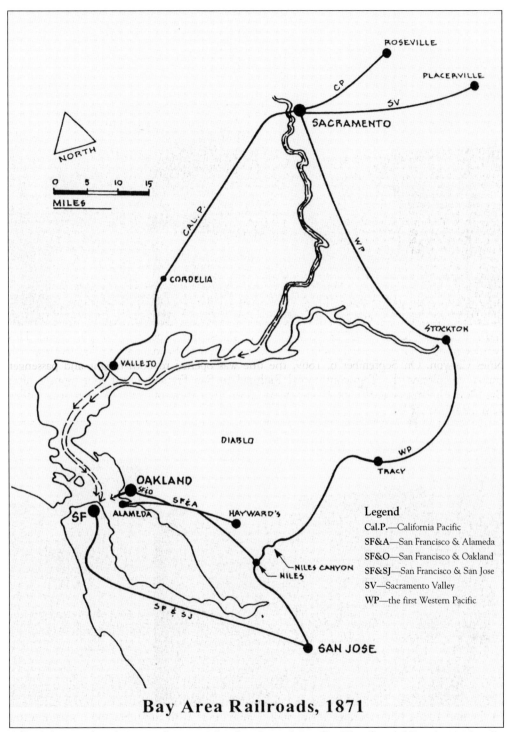

Bay Area Railroads, 1871

Legend
Cal.P.—California Pacific
SF&A—San Francisco & Alameda
SF&O—San Francisco & Oakland
SF&SJ—San Francisco & San Jose
SV—Sacramento Valley
WP—the first Western Pacific

All of these railroads were taken over by the Central Pacific. The Central Pacific, under the Western Pacific name, built the Western Pacific line from Sacramento to Niles Canyon. Central Pacific became Southern Pacific in 1885. (Map by Charles Endom; courtesy of Randy Hees.)

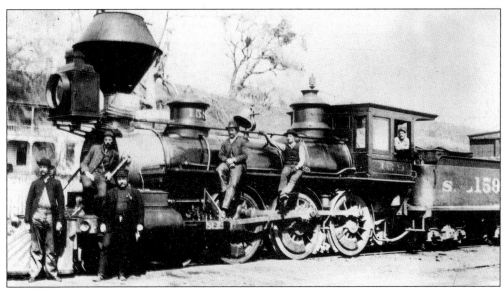

Southern Pacific No. 159 pauses in downtown Sunol in this *c.* 1899 image. As this 4-6-0 was normally assigned to Southern California, it was an oddity in Niles Canyon. This could explain why a few of the local residents are posing with this locomotive. The Glen Ellen Hotel, largest and most ornate of Sunol's four hotels, is in the background. (Courtesy of Amador-Livermore Valley Historical Society.)

This classic image captures the feel of Niles Canyon, as a Southern Pacific Picnic Special appears out of the morning fog and charges past a semaphore on the nearly one-percent climb at Milepost 31 between Dresser and Farwell Bridges. Fern Brook Park is the destination. Action photos of trains prior to 1900 are quite rare, as most cameras of the day couldn't keep a moving train in focus. (Frank Trahan photo; courtesy of Southern Pacific Valuation Department.)

Looking south in this bird's-eye view of Niles in the 1880s, the original Niles depot can be seen on the far right, with the engine house and turntable directly behind it. Niles was and is an important rail junction. Lines went east to Tracy and Stockton, south to San Francisco via San Jose, and north to Oakland. (Mayhew Collection; courtesy of Museum of Local History, Fremont.)

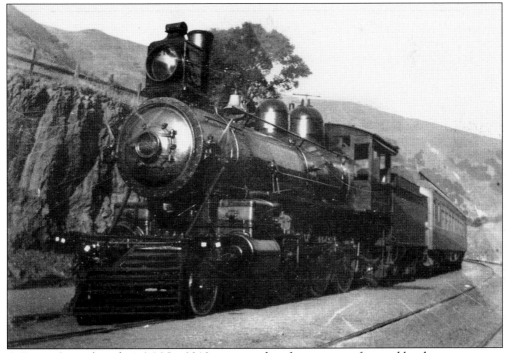

A Picnic Special, with 4-6-0 No. 2219, waits in the afternoon sun for tired but happy guests to board for the return trip to Oakland. Niles Canyon was popular for weekend Picnic Specials through the 1930s. the canyon was lined with "resorts" featuring open-air dance pavilions, swimming in Alameda Creek, picnicking facilities, and generous bartenders. (Frank Trahan photo; courtesy of Pacific Locomotive Association.)

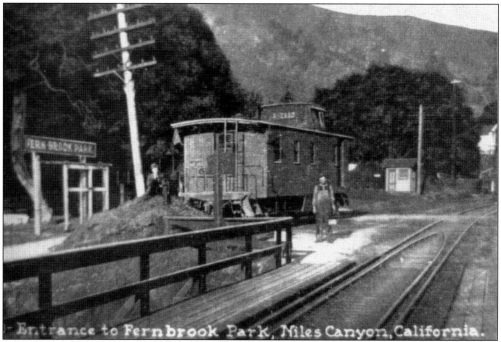

Entrance to Fernbrook Park, Niles Canyon, California.

The camera that captured this scene is on Farwell Bridge, looking east. To the left, the "Fern Brook Park" entrance sign is on Palomares Road. The wooden caboose, sitting at the end of the Farwell siding, may be doubling as a temporary ticket office and waiting room. (Meyer Collection; courtesy of Phil Holmes.)

Niles Canyon Picnic Grounds

W. W. Dugan, Prop. - - - Niles. Cal.

Handsomest and Most Popular
PICNIC AND CAMPING
Grounds in Alameda County.

SULPHUR SPRINGS ON THE GROUNDS.

Dinners Served to Private Parties at Short Notice. First Class Restaurant.
Meals at all Hours. All Trains Stop at the Grounds.

A June 17, 1898 newspaper advertises Niles Canyon picnic grounds. Outdoor facilities were very competitive. Even John Philip Sousa and his 35-piece band entertained in the canyon in 1915. Roundtrip train fare from Oakland directly to the grounds, which were located just inside the canyon near Niles, was $1 at the time. (Courtesy of Phil Holmes collection.)

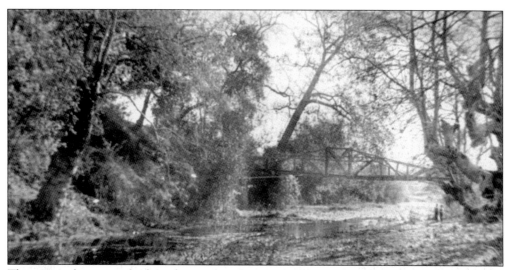

The tranquil waters of Alameda Creek reflect the walking bridge to Joyland Park, located on the left. Fern Brook Park, which later became Stoney Brook Park, was at the eastern end of Farwell Bridge, with Joyland Park at the western end. Most fun seekers arrived by train. The track is just up the hill, out of sight, on the left. The bridge foundations and some of the barbeque facilities can still be seen today. (Courtesy of Museum of Local History, Fremont.)

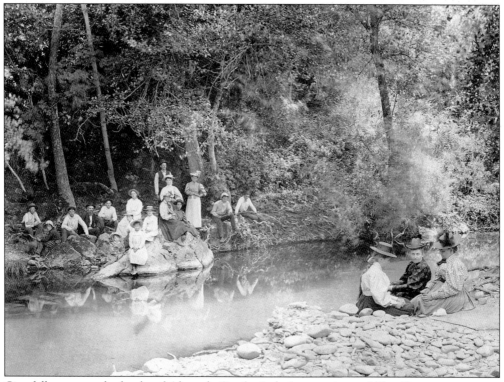

City folk pose on the banks of Alameda Creek. A day's excursion to Niles Canyon meant one dressed for the occasion. Rowboats were available for rent and fishing was popular. But when the train's whistle blew, it was time to get aboard unless you wanted to spend the night, counting stars. (Dr. Robert B. Fisher Collection; courtesy of Museum of Local History, Fremont.)

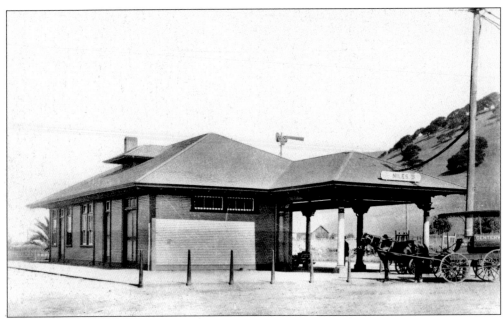

The order board signal, seen above the depot's roofline, is set so that train orders, telegraphed from the dispatcher, can be passed on to the engineer and conductor by the Niles station agent. Most railway stations had their quiet times occasionally pierced by moments of "train time" excitement. But until the train arrives, it's rest time for the one-horse station wagon, waiting for the Centerville mail. (Courtesy of Henry Bender collection.)

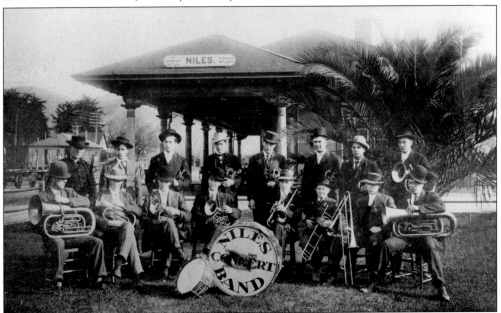

The new Niles depot was the location of many local functions over the years, including musical welcomes or farewells for famous guests. The Niles Concert Band is now gone, and the depot has been moved to another location, but the Canary Island palm tree remains and has grown dramatically over the years. Southern Pacific planted palms at most of their warm-weather depots. (Courtesy of Henry Bender collection.)

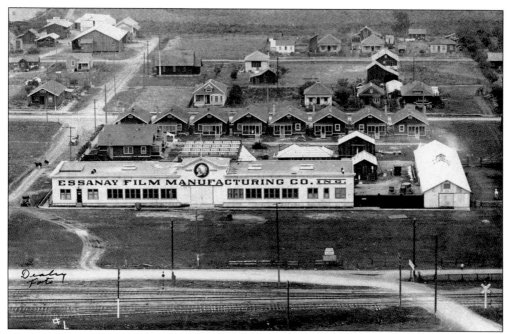

Moviemaking came to Niles in 1912 when Essanay built their $50,000 film studios on Front Street—now Niles Boulevard—facing the Southern Pacific tracks. Red bungalows, built for Essanay personnel, line Second Street behind the studio. Hundreds of short silents were made here until 1916, when filmmaking began to consolidate in Hollywood. (Courtesy of Niles Essanay Silent Film Museum.)

Gilbert M. "Bronco Billy" Anderson, the world's first Western movie star, poses on Second Street in Niles in 1912. He and his Chicago-based partner, George K. Spoor, were the "S" and "A" in Essanay. Each week, two to five movie one-reelers, each 15 minutes long, were made in Niles. (Courtesy of Niles Essanay Silent Film Museum.)

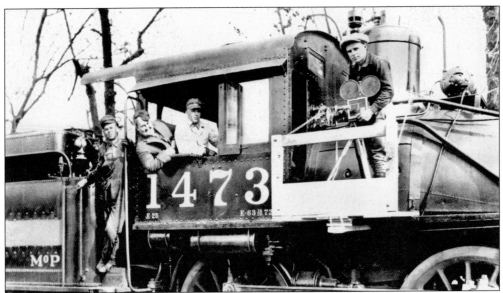

No. 1473, an Southern Pacific 4-4-0 American type, stars in *County Fair*, being filmed in Pleasanton by Essanay. Actor Walter Heirs, sitting behind Engineer Mac MacElroy, has replaced Fatty Arbuckle, who was in San Francisco sorting out his troubles at the time. "MoP" on the tender was painted to look like Missouri Pacific RR. This film premiered at the Niles Theatre. (Vernon Sappers Collection; courtesy of Western Railway Museum.)

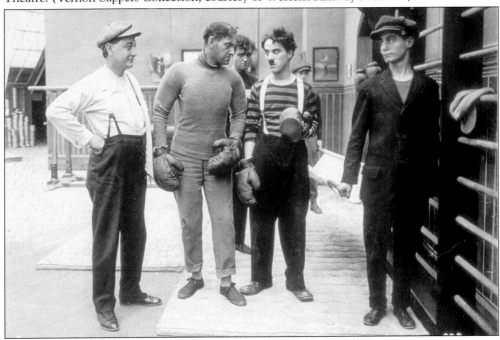

Essanay's brightest star was Charlie Chaplin, squaring off here with Ernest Van Pelt in *The Champion*, filmed in 1915. Chaplin made several movies in and around Niles, including *The Tramp*, with its famous Niles Canyon scene, walking down the dusty road. The railroad and the canyon were often included in Essanay films, especially the Bronco Billy epics. (Photo courtesy of Sam Gill.)

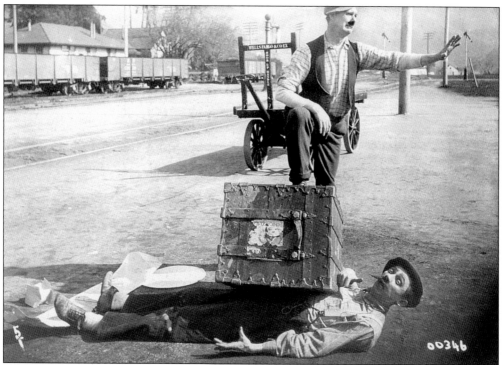

The Niles depot was the scene for filming *A Horse of Another Color* with Victor Potel as Assistant Baggage Master Slippery Slim (on the ground) and Harry Todd, playing Baggage Master Mustang Pete. Behind the Wells Fargo baggage cart is the wye leading into Niles Canyon. (Courtesy of Niles of Essanay Silent Film Museum.)

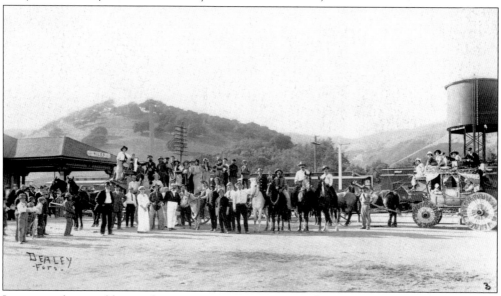

In a scene that would scare the average arriving passenger, the entire Essanay Company turned out at the Niles depot on November 23, 1914, awaiting Victor Potel and his bride. When the train arrived, a procession escorted the newlyweds to the nearby studios. (Niles Essanay Silent Film Museum Collection; courtesy of Dealey family.)

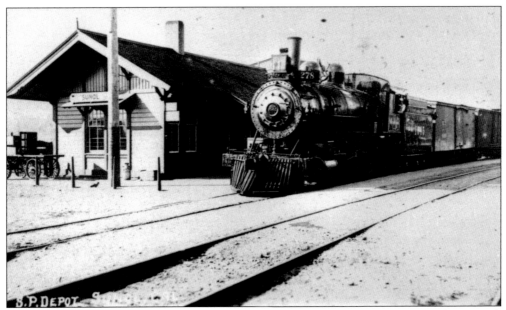

A scheduled eastbound freight pauses at Sunol with its front coupler sitting on Kilkare Road. This train will continue on to Pleasanton, Livermore, and Altamont Pass before reaching Tracy later in the day. All scheduled freight and passenger trains of the Southern Pacific displayed their train numbers in the locomotive's number boards. (Courtesy of Amador-Livermore Valley Historical Society.)

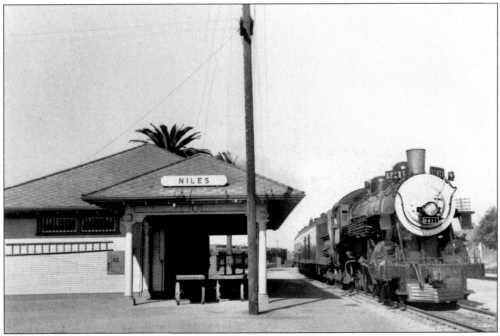

No. 2411, a 4-6-2, pulls into the Niles station in 1953 with a passenger "extra" as indicated by the "X" in the number boards. As a smaller "light" Pacific, this type of locomotive was preferred power for short passenger trains and for lighter rail, such as the Los Gatos and Monterey branches. (Courtesy of Arthur Lloyd.)

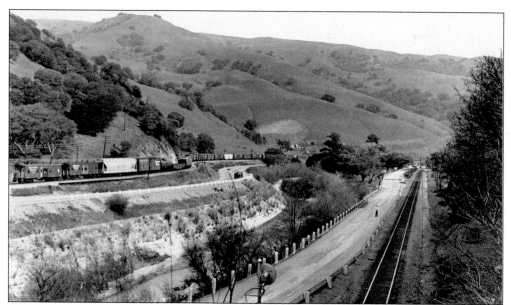

The saying "A picture is worth a thousand words" certainly applies here. Seen in this photo on the left is the original rail line through the canyon, occupied by a Southern Pacific train now used by the Niles Canyon Railway. An improved State Highway 84 parallels these tracks. Alameda Creek flows down the middle of the canyon, next to the old highway. Furthest right is the "new" Western Pacific line, built with fewer curves and more gradual grades, presently owned by Union Pacific. (Courtesy of Joe Ward.)

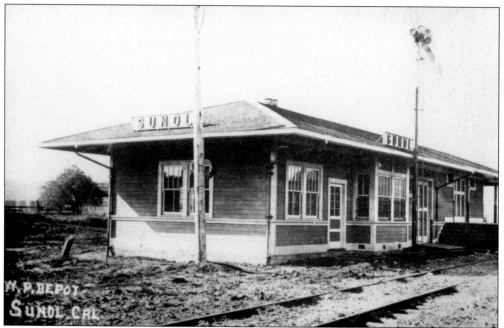

Western Pacific's Sunol depot saw very few passengers as the town had only a few hundred people and limited passenger service. This building was sold and moved to become a local residence. All three population centers associated with Niles Canyon had at least two depots available to serve their residents. (Courtesy of Amador-Livermore Valley Historical Society collection.)

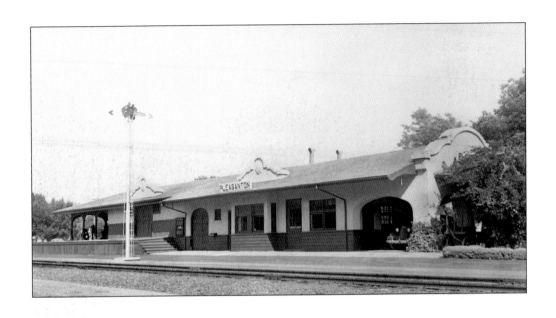

Both Pleasanton (above) and Niles/Fremont stations provided high passenger counts for Western Pacific trains due to their proximity to the population base. San Jose and other South Bay patrons found the Niles/Fremont route most convenient when traveling on the Western Pacific. (Both Will Whittaker photos; courtesy of Henry Bender collection.)

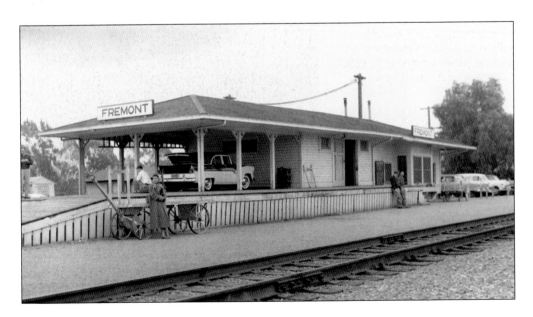

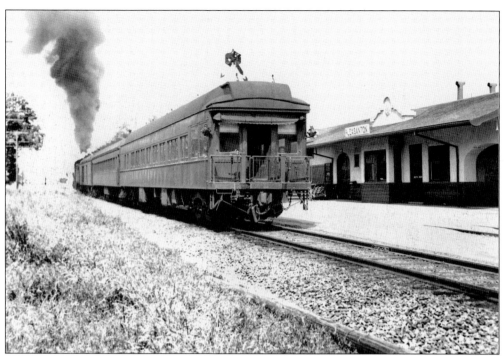

Western Pacific 4-6-0 No. 77 leaves Pleasanton with train No. 12 on May 2, 1943. Western Pacific preferred this wheel arrangement for passenger trains. Boasting that the maximum grade on their entire line from Oakland to Salt Lake City never exceeded one percent, their relatively small 10-wheeler, as a 4-6-0 is called, was usually sufficient to keep their three- or four-car passenger trains on time. (Courtesy of Arthur Lloyd.)

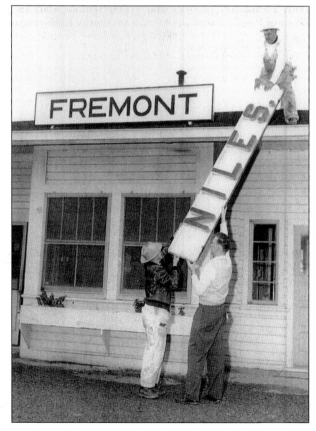

The Niles sign comes down, and the Fremont sign goes up at the Shinn Street depot. The year was 1956. Fremont was formed when the independent towns of Niles, Centerville, Warm Springs, Irvington, and Mission San Jose united. Fremont remained a busy station serving Western Pacific's remaining passenger fleet. (Courtesy of Wes Hammond and the Museum of Local History, Fremont.)

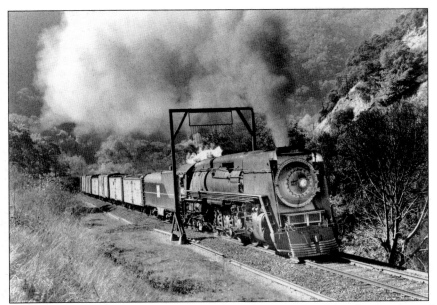

Western Pacific's "Baby Daylight" No. 483 was originally ordered by the Southern Pacific. During World War II, the federal government took over America's locomotive builders and assigned completed engines to various railroads on an as-needed basis. This resulted in Western Pacific receiving six of these Southern Pacific-designed 4-8-4 Northerns to supplement their badly worn steam fleet. One sister Southern Pacific Baby Daylight survives today, No. 4460, on display at the National Museum of Transportation in St. Louis. (John Illman photo; courtesy of Dick Dorn collection.)

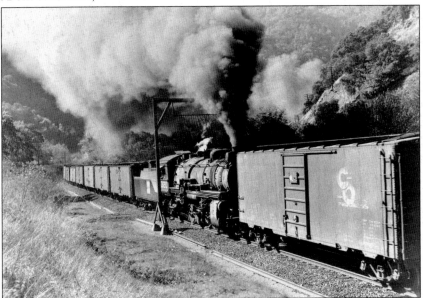

No. 483 was assisted by mid-train helper 2-8-2 Mikado No. 320, as this heavy eastbound train of nearly all reefers filled with California produce exits tunnel No. 2 between Niles and Sunol on November 9, 1950. Western Pacific was never considered a wealthy railroad. Secondhand locomotives and passenger cars were not unusual on the Western Pacific mainline. (John Illman photo; courtesy of Dick Dorn collection.)

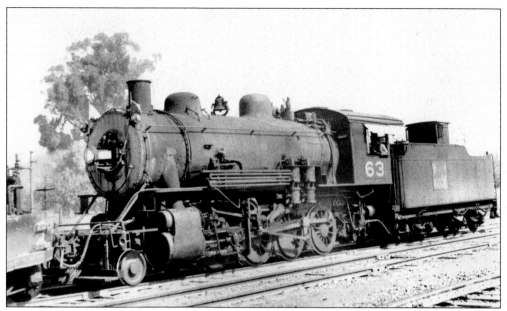

Another popular wheel arrangement is found on No. 63, a 2-8-0, known as a consolidation, seen here in local service at Niles in 1950. Western Pacific used these versatile freight engines for both mainline and switching duties. (Courtesy of Arthur Lloyd.)

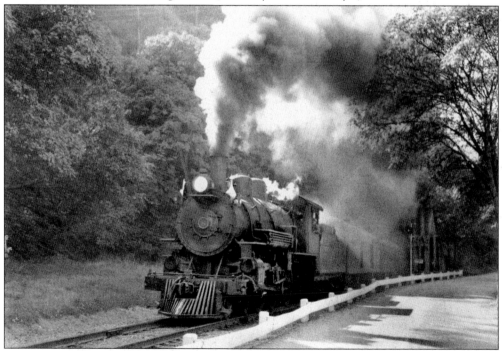

Steam trains, such as No. 94, pictured above on October 21, 1956, occasionally visited Niles Canyon on rail fan excursion trains long after the railroad switched to diesel. This 4-6-0 had the dubious honor of being the last Western Pacific engine under steam. It was donated to the Western Railway Museum at Rio Vista Junction, where it remains today, keeping company with another donated engine, Western Pacific 2-8-2 No. 334. (Courtesy of Don Hansen.)

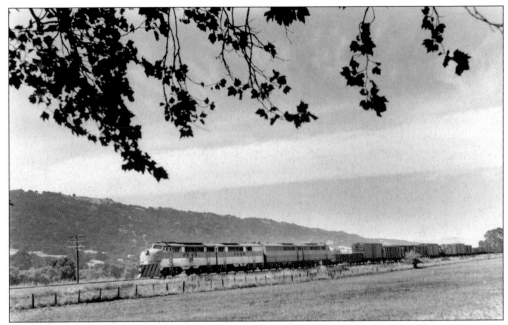

On a pleasant September day in 1952, four F-3, first-generation diesel locomotives—two in the latest silver and orange color scheme, and two in the original green and yellow—haul extra 904A west at Pleasanton. Realizing the economy of diesel over steam, Western Pacific was one of the first railroads in America to become fully dieselized. (John Illman photo; courtesy of Dick Dorn collection.)

A trio of more modern GP-20 locomotives, with 2009 in the lead, rolls downhill through Niles Canyon en route to Oakland in March of 1970. The "GP" refers to General Purpose, and accounts for the nickname, *Geep*. (John Illman photo; courtesy of Dick Dorn collection.)

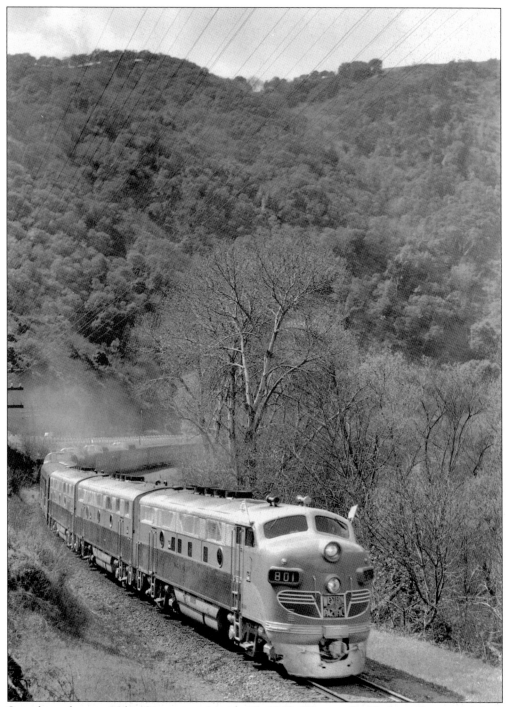

Seen here deep in Niles Canyon on March 20, 1949, Western Pacific hosted a special from Oakland to Carbona (near Tracy) and back for radio and newspaper people, along with invited guests. The Western Pacific wanted to introduce their brand new train, the *California Zephyr*, to the world. With white flags on the cab roof, this train was special indeed, featuring five Vista Dome cars on each train set. (John Illman photo; courtesy of Dick Dorn collection.)

Approaching Sunol while overtaking an Southern Pacific freight in October of 1958, the *California Zephyr,* known as the "finest train in the world," passes through the canyon each day en route to and from Chicago. Western Pacific operated the train between Oakland and Salt Lake City, where another railroad took over. From its first day in 1949 to its last day in 1970, the *Zephyr* maintained the highest standards of quality and service. (Courtesy of Don Hansen.)

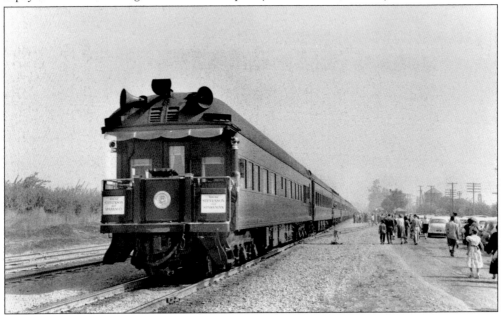

It's October 5, 1952, and down at Western Pacific's Niles station the Adlai Stevenson campaign train pulls into town. On the rear is the private car *Magellan,* complete with sedate "Vote for Stevenson" signs. Harry Truman and his daughter Margaret were aboard the *Magellan,* and the crowd was not disappointed. Stevenson gave a short speech from the rear platform during the stop at Niles. (John Illman photo; courtesy of Dick Dorn collection.)

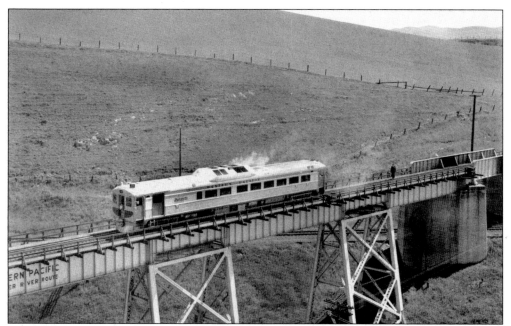

Shortly after leaving Niles Canyon, Western Pacific's *Zephyrette* begins climbing Altamont Pass. The self-powered, single RDC (Rail Diesel Car) was lightly patronized, but a favorite with pass riders, and met the ICC requirement to provide local service. All stops were made on its three-times-a-week schedule to Salt Lake City. (Courtesy of Arthur Lloyd.)

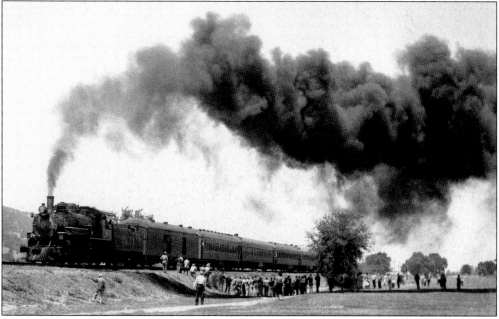

A photo run-by in the middle of the exclusive Castlewood Country Club, near Sunol, surprised several golfers. Although Castlewood was the home of William Randolph Hearst's mother, Phoebe Apperson Hearst, for a few minutes on June 7, 1959, it belonged to those riding the special. Western Pacific's public relations department did an excellent job keeping 4-6-0 No. 94 available for special events and fan trips. (Author's photo.)

To proceed beyond Niles Junction, the engineer of the Union Pacific manifest freight, en route from Roseville to San Jose, uses his cell phone to to request permission from the dispatcher in Omaha. Union Pacific has grown from its pioneer days at Promontory to become the big winner by taking control of every major California railroad, except the Santa Fe. (Author's photo.)

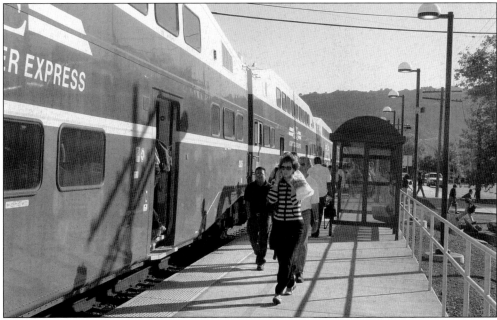

An Altamont Commuter Express train exchanges passengers at Pleasanton before continuing on to Livermore, Tracy and Stockton. ACE trains travel over the Union Pacific (ex-Western Pacific) line through Niles Canyon from the distant suburbs to Santa Clara's Silicon Valley and San Jose on weekdays only. (Author's photo.)

Two

THE SOUTHERN PACIFIC ERA

FROM STEAM TO ABANDONMENT

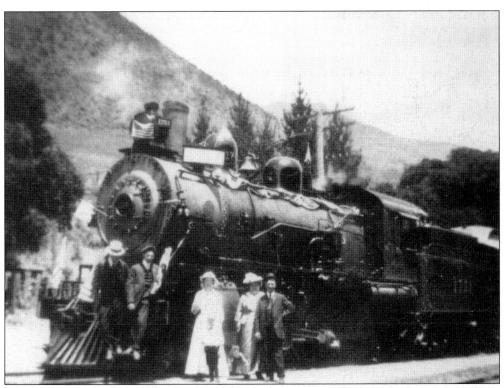

Southern Pacific Mogul-type 2-6-0 No. 1751 and friends pose at Niles in 1907. The same people associated with the San Francisco & San Jose Railroad started the Southern Pacific when they built the first Southern Pacific track from San Jose to Tres Piños, south of Hollister. Both SJ & SF and the Southern Pacific were taken over by the Central Pacific in 1870. From this humble beginning, the mighty empire developed. (Courtesy of Museum of Local History, Fremont.)

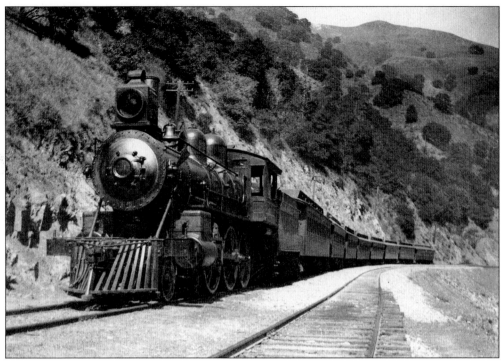

With eight wooden coaches attached, Southern Pacific 4-6-0 No. 2216 simmers patiently as railroad employees enjoy a picnic at nearby Stoney Brook Park in 1902. Wooden coaches had a tendency to disintegrate in accidents, resulting in a high rate of injuries and deaths. They were soon replaced by new all-steel cars, making rail one of the safest ways to travel, a claim that remains true to this very day. (Courtesy of Pacific Locomotive Association.)

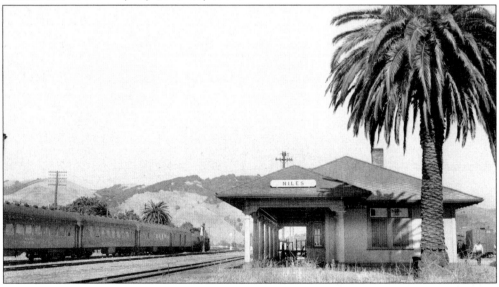

A passenger extra stops to take water at Niles in 1947. Although regular passenger service was discontinued through Niles Canyon in 1941, extras such as this could still be found on rare occasions. Note how the palm tree has grown. (Will Whittaker photo; courtesy of Henry Bender collection.)

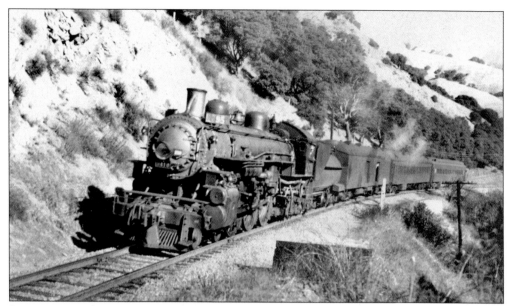

Passenger Local No. 95, en route from Fresno to Oakland, drifts downhill on its westbound journey through the canyon. Here we find a Depression-era, three-car train, typical of the 1930s, consisting of a baggage-post office car and two nearly empty coaches on December 11, 1938. (Will Whittaker photo; courtesy of Arnold Menke collection.)

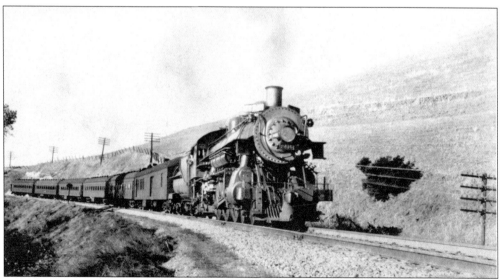

On the same day, Oakland to Tracy Local No. 234 leaves Niles with extra coaches to accommodate a large group. No. 2415 has been serving the Southern Pacific for 32 years, ever since it was new in 1906. (Will Whittaker photo; courtesy of Arnold Menke collection.)

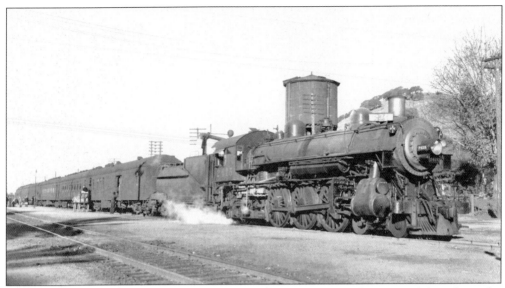

In this 1938 scene, Fresno bound No. 2415 takes water from the spring-fed tank in the background. Niles had a convenient water column that could be swung in either direction, servicing two adjacent tracks. (Courtesy of Arnold Menke collection.)

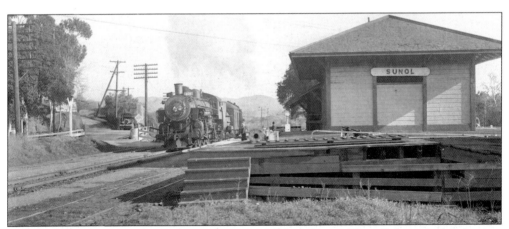

A hay truck waits to cross the tracks as engine No. 2449, with one of Sunol's last scheduled trains, blocks Kilkare Road on January 12, shortly before passenger service ended on January 25, 1941. The depot had closed years before, and the order-board signal has been taken down and left on the freight platform. (Robert Searle photo; courtesy of Pacific Locomotive Association.)

On a cool February morning, cab forward No. 4122 steams eastbound toward Brightside with train No. 406. These 4-8-8-2 articulated consolidated giants were often routed through the canyon as a shortcut, avoiding congested freight yards around Oakland. Very heavy trains could find a second 4-8-8-2 engine added to the first engine (known as doubleheading) or placed somewhere back in the train. (John Illman photo; courtesy of Dick Dorn collection.)

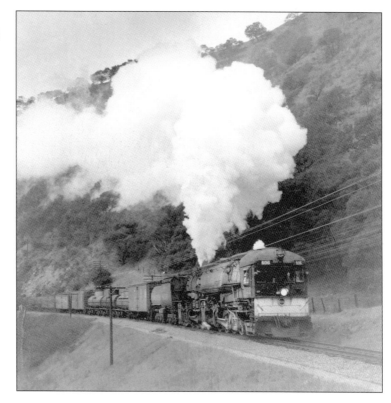

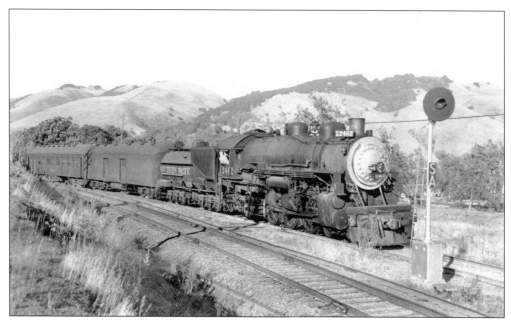

Pacific No. 2462 comes out of the canyon and takes the southbound leg of the Niles wye with a passenger extra on June 29, 1948. For improved visibility and safety, smokebox fronts have been painted silver and now adorn all Southern Pacific steam engines, both freight and passenger. (Will Whittaker photo; courtesy of Arnold Menke collection.)

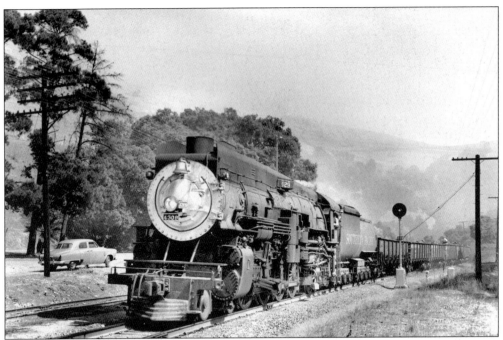

Snaking through the "S" curve on the approach to Farwell Bridge, No. 4309 eases train No. 429 along the main line toward Niles on October 5, 1952. A favorite of Southern Pacific engine crews, 4-8-2 mountain type locomotives such as this were used on both fast freight and passenger trains. Southern Pacific built most of the 4300s in the Sacramento shops. (John Illman photo; courtesy of Dick Dorn collection.)

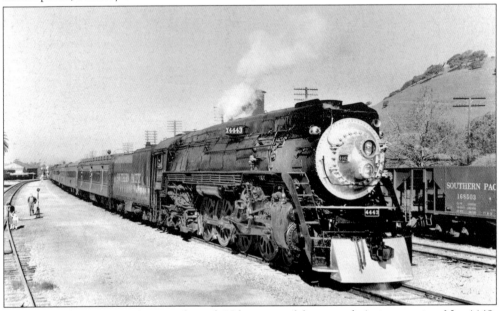

On another day, extra 4443 passes through Niles on a rail fan special. A sister engine, No. 4449, is the only remaining *Daylight* steam engine, and still sees occasional action. Excursion specials such as this have been a popular railroad tradition that continues to this very day. (John Illman photo; courtesy of Dick Dorn collection.)

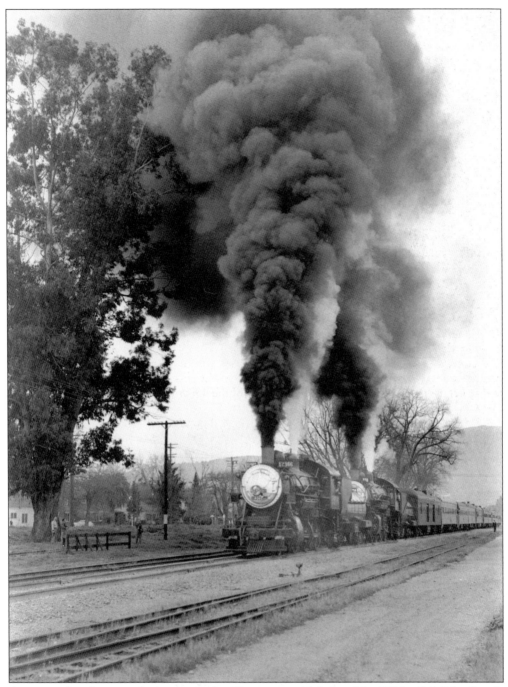

A spectacular photo run-by is presented at Pleasanton with helper No. 1806, a 2-6-0, leading 4-6-0 No. 2366 on a March 21, 1955 excursion extra headed for the San Joaquin Valley. From the 1920s until the end of steam, Southern Pacific's 2-6-0s were commonly used in freight service only, while 4-6-0s provided power for both freight and passenger trains. (John Illman photo; courtesy of Dick Dorn collection.)

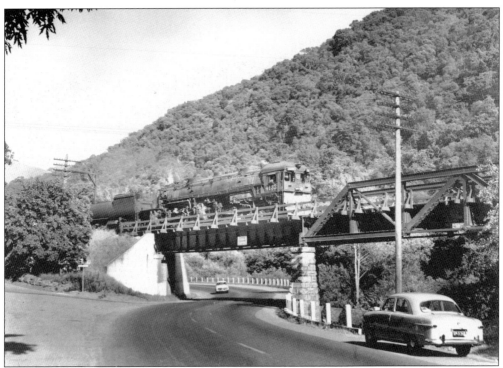

The early 1950s saw steam locomotives being concentrated closer to the Bay Area each year as diesels conquered larger portions of the Southern Pacific system. On May 28, 1955, one of the oldest cab forwards, flat fronted No. 4133, crosses Farwell Bridge at a location once known as Fern Brook Park. (Courtesy of Stan Kistler.)

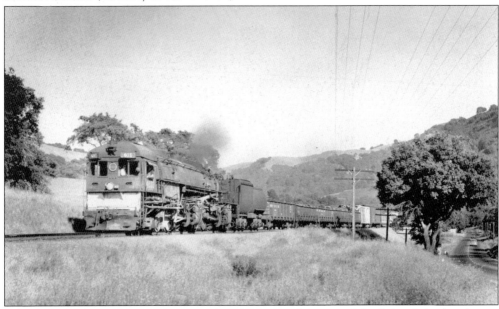

Farther down the canyon on the same day, the center dump gondolas behind the engine are filled with ballast rock from Radum, near Pleasanton. The train, heading for San Jose, is seen just past Brightside at Estates Crossing. (Courtesy of Stan Kistler.)

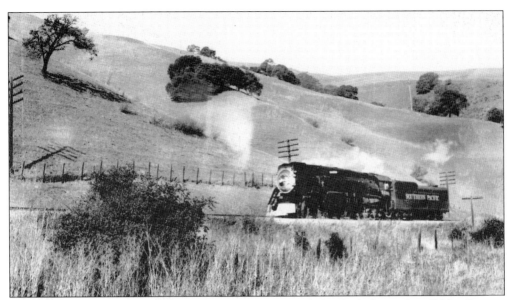

Heavy freight trains would require a second locomotive to help climb the grades of Niles Canyon and Altamont Pass. Steam was being replaced by new diesels, and some unusual situations resulted, such as a speedy 4-8-4 seeing duty as helper engine No. 4410, drifting downhill, deadheads toward Niles for another call to duty. (Courtesy of Western Railway Museum.)

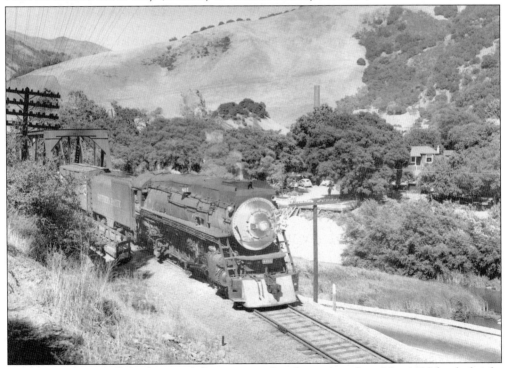

Defrocked of its *Daylight* skirts and distinctive red and orange colors, No. 4410 hauls freight in 1955, shortly before retirement. The GS-1 class 4-8-4 crosses Dresser Bridge over Highway 84 en route to Niles. The smokestack in the background is part of the California Pressed Brick Company plant. (Courtesy of Stan Kistler.)

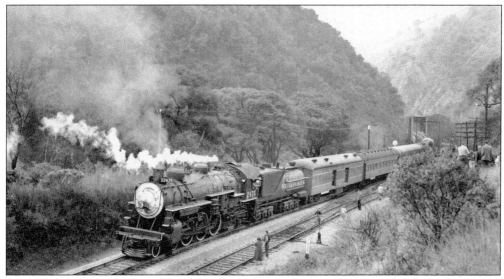

The first of two "Last Run of Steam" excursions in 1958 traveled from San Jose to Tracy on New Years Day with 4-6-2 No. 2475. A short stop lets passengers off the train prior to a photo run-by over Farwell Bridge. The whitewall tires were added for the occasion. (Will Whittaker photo; courtesy of Arnold Menke collection.)

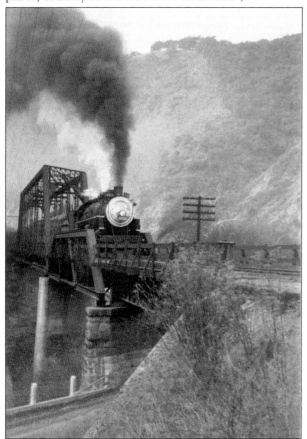

Complete with all the "bells and whistles" necessary for a good photo, No. 2475 charges across Farwell Bridge under a plume of serious smoke. The Niles Canyon Railway logo was based on this picture. (Author's photo.)

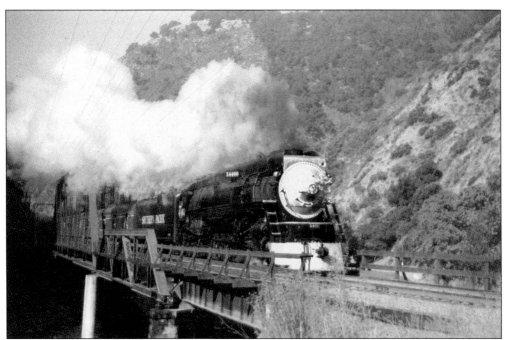

High-stepping over Farwell Bridge, No. 4460 is creating history as the last Southern Pacific steam locomotive to operate in Niles Canyon. The date is March 25, 1958, and the GS-6 class 4-8-4 is pulling the Fresno Flyer special which will take the west side line down the valley to the train's namesake city. (Author's photo.)

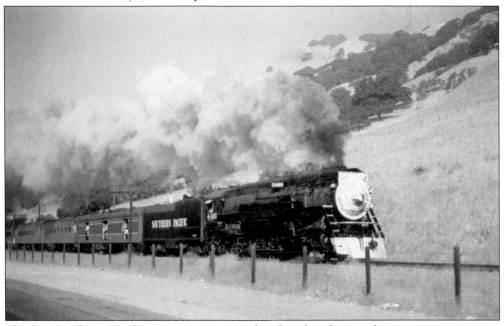

The last Southern Pacific steam train approaches Sunol with its eight-car train en route to Fresno. An "overachiever" at Brisbane's Bayshore Shops was carried away with the silver paint, catching the front of the Skyline casing along with the traditional smokebox front. (Author's photo.)

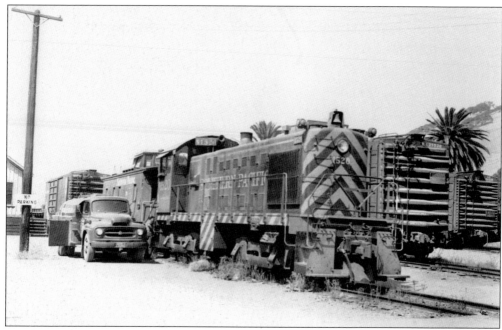

A 1953 product of American Locomotive Co. (Alco), Southern Pacific No. 1520 takes fuel while the crew eats lunch across the street in downtown Niles in September 1958. When "first generation" diesels such as this replaced 2-6-0 and 2-8-0 steam locomotives, railroads gained economically, but lost much public attentiveness. (Courtesy of Don Hansen.)

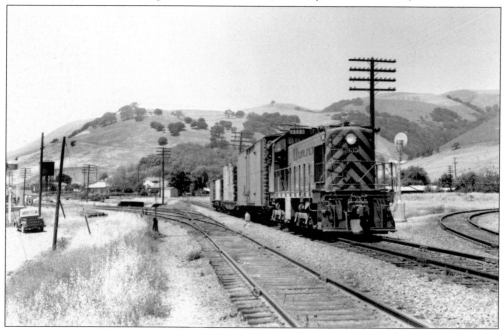

General Motors EMD (ElectroMotive Division) switcher No. 1435 and train on the main are shown here, heading south to Warm Springs on a warm May 18, 1959 day. The south leg of the wye, curving to the right, leads into the canyon. In the background is the Niles water tank. (Courtesy of Don Hansen.)

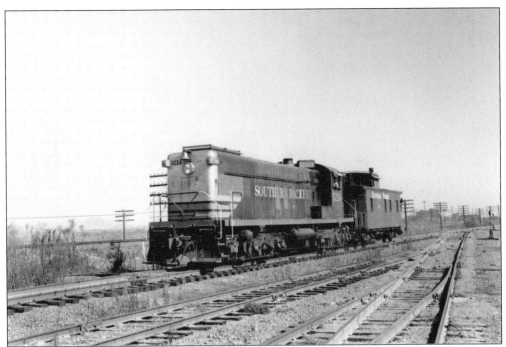

An eight-year-old Baldwin road switcher No. 5214 departs Pleasanton on a caboose-hop headed for Niles on a crisp November 1958 day. The large Baldwins worked well on the heavy rock trains originating at the nearby Kaiser plant at Radum, and were commonly seen rolling through Niles Canyon. (Courtesy of Don Hansen.)

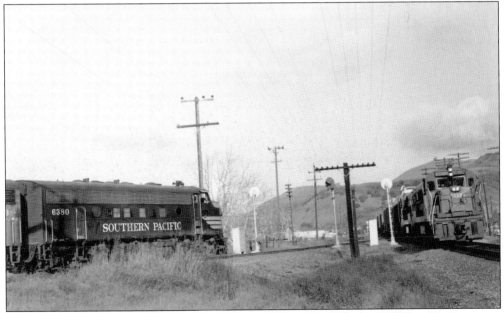

It's train time at Niles as Southern Pacific No. 7557, a General Electric U25B in the latest gray with scarlet stripes paint scheme, heads south carrying general freight. Waiting patiently at the red signal is Black Widow F7 No. 6380. When the southbound train clears the wye, No. 6380 will get a green to enter the canyon. (Courtesy of Don Hansen.)

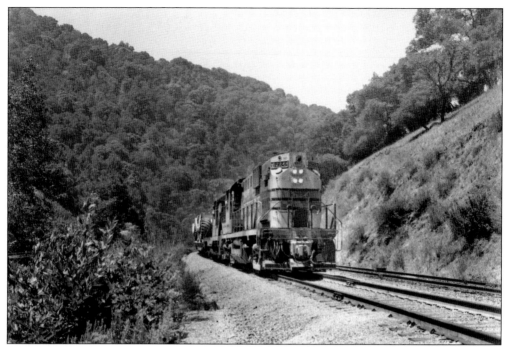

In "Black Widow" paint schemes, Alco Nos. 5722 and 5643 approach The Spot on this cloudless July day in 1959. Early Baldwin and Alco road switchers were ordered by the Southern Pacific to "long nose forward," limiting the engineer's view. These were later rebuilt by the railroad to the more conventional short end forward. (Courtesy of Don Hansen.)

Forsaken after 115 years of service, the Southern Pacific line through Niles Canyon and over Altamont Pass lay deserted in 1984 in favor of trackage rights over the parallel Western Pacific tracks. Rails, switches, signals, and everything of value were removed by the railroad, leaving only the right-of-way and bridges to be turned over to Alameda County. (Author's photo.)

Three

REBUILDING
THE RAILROAD

RESTORATION BY VOLUNTEERS

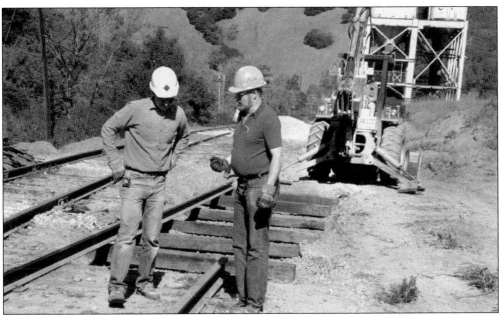

Every project, regardless of the task, starts somewhere. Rebuilding this portion of America's original Transcontinental Railroad started in 1987 at the old Kaiser Kailite tipple at Brightside and slowly was extended to Sunol. This section was constructed in the same manner as the original 1860s railroad—with spike mauls and muscles only. Mike McQuaid (on the left) and Gerry Dewees discuss plans. (Courtesy of Warren Benner photo.)

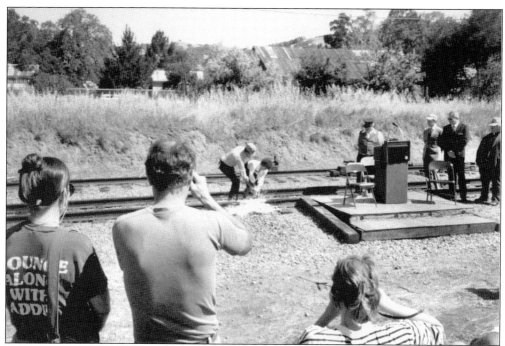

On May 21, 1988, track crew volunteer Mark Whitman officially opens the Niles Canyon Railway museum from Sunol to Brightside. Volunteer members of the non-profit Pacific Locomotive Association accomplish all work on the railway, from building to operating. (Courtesy of Warren Benner.)

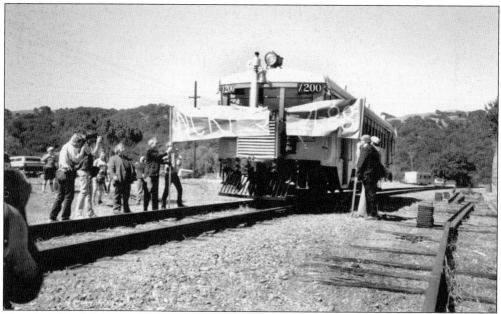

The opening ceremony was followed by Skunk railcar M200 splitting the banner to become the first Niles Canyon Railway train to arrive at Sunol. Opening-day rides were given over this nearly 1½-mile section of the railroad for the remainder of the day. (Courtesy of Warren Benner.)

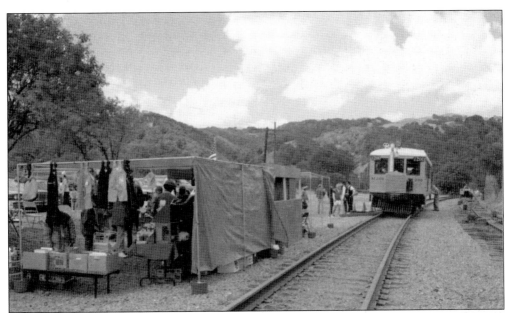

The Sunol station consisted of a canvas tent-like structure that had a tendency to fly away with the afternoon winds. Both the ticket office and the portable souvenir shop received a fine dusting from the dirt parking lot traffic. The M200 loads passengers in the background for another run to Brightside and back. (Courtesy of Warren Benner.)

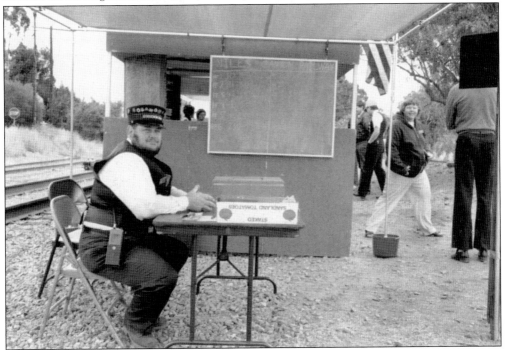

Primitive facilities greet passengers in the early days of Niles Canyon Railroad. At the open-air Sunol depot, Ticket Agent Matt Maksell dispenses free tickets for roundtrip rides on the M200. There was no charge, but donations were welcome—a policy that remains today. (Courtesy of Warren Benner.)

The M200 prepares to depart Sunol in this early photo of the Niles Canyon Railway. Items missing from this picture that have been added since include the return of the original Sunol depot, a smooth Kilkare Road crossing, completed track in the foreground, a passing siding, signal gates, paved parking lot, and landscaped depot gardens. (Courtesy of Warren Benner.)

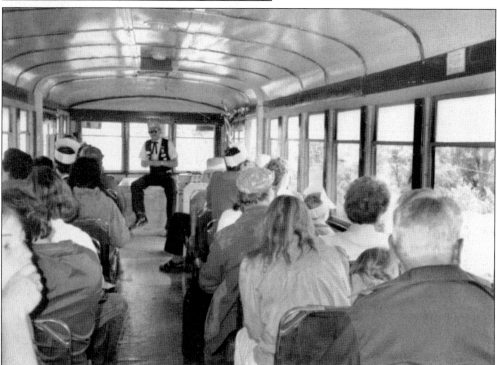

On one of the first days of operation, conductor Alan Ramsay narrates the history of Niles Canyon and the railway as the Skunk travels nearly one and a half miles along the recently restored rail line. (Courtesy of Warren Benner.)

The second section of right-of-way to be restored extended westward from Brightside to Farwell Bridge, a distance of about 2½ miles. This is the scene that greeted the track crew when the company Peterbilt arrived to drop off track-building supplies. (Courtesy of the author.)

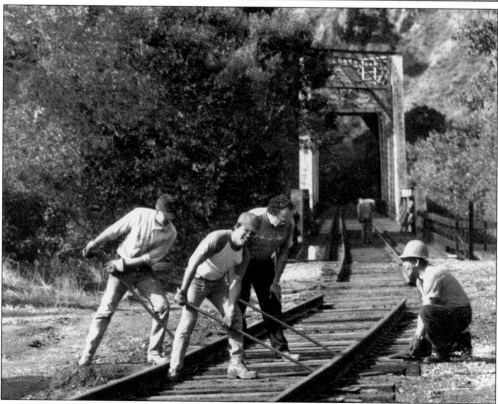

By 1991, track is nearly completed to Farwell Bridge, with only two rails still to be placed. Aligning the rails to the proper 4-foot, 8½-inch gauge, from left to right, are Alan Siegwarth, Allen Teruya, Jeff Otto, and Doug Shannon. (Courtesy of Alan Frank.)

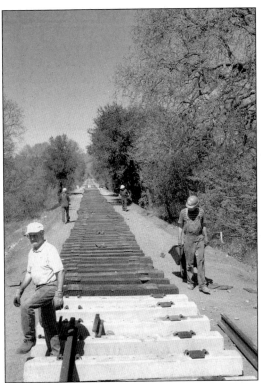

A great amount of material is needed to build railroad track. Union Pacific Railroad generously provided surplus rail to replace the rail Southern Pacific pulled up. Additional rails, ties, and material were salvaged from a variety of unused rail lines by the track crew, including a section of concrete ties. (Courtesy of Patrice Warren.)

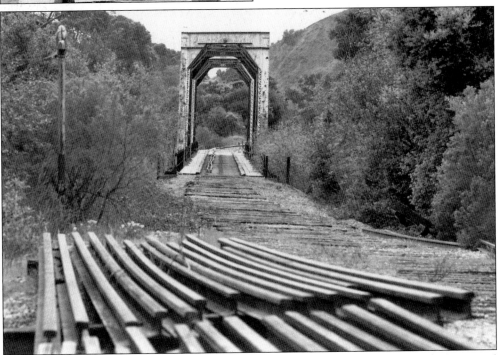

The Dresser Bridge, dating from 1906, stands forlorn over Alameda Creek awaiting the arrival of the track crew to restore rails that have already been delivered to the location. (Courtesy of Alan Frank.)

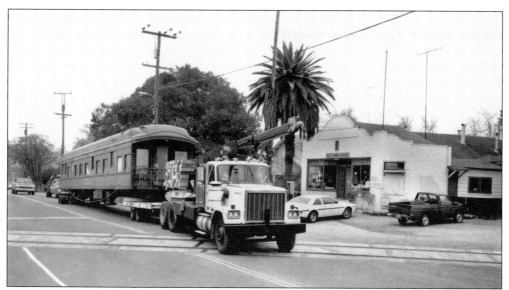

Coming from display at Oakland's Harrison Park, Southern Pacific business car *Western* rolls past the Towne House Café in downtown Sunol just prior to delivery to the railroad. All locomotives and cars arrived by truck until a rail connection with the Union Pacific was made in September 2004.

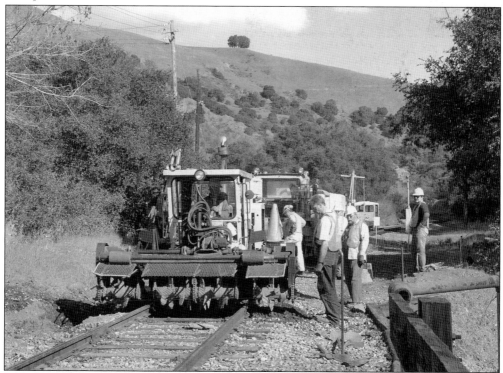

A small fleet of maintenance-of-way machines, added over the years, allows track to be built in a fraction of the time it took to complete the first mile. From left to right are Hugh Tebault, Steve Jones, Chris Campi, Peter Stewart, Henry Baum, and Joe Rodriguez. (Courtesy of Patrice Warren.)

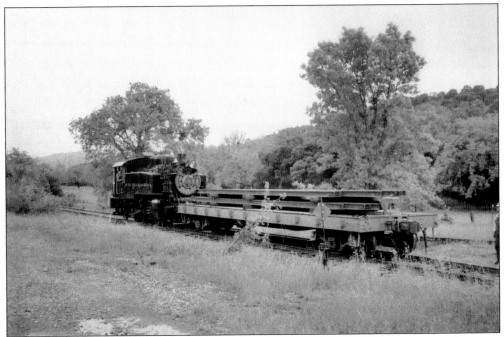

As rails are extended, supplies are delivered to the track crew by work train. Quincy Railroad No. 2 takes the siding at Hearst for the first time in July 2004 with rail for the Union Pacific connection. (Courtesy of Alan Siegwarth.)

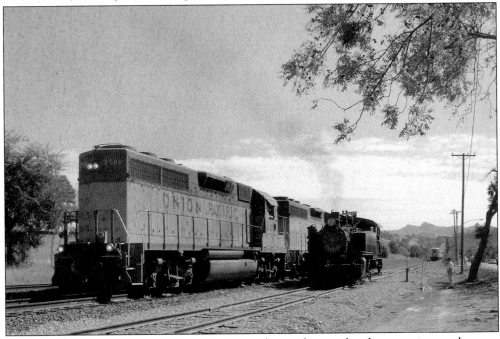

Quincy RR No. 2 became the first engine to use the newly completed connection track across the Pleasanton-Sunol Road on October 13, 2004. The occasion was to pick up three coaches, leased from CalTrain, which had been set out on the siding by the Union Pacific freight. (Courtesy of Alan Siegwarth.)

Four

NILES CANYON RAILWAY
TODAY'S TRAINS

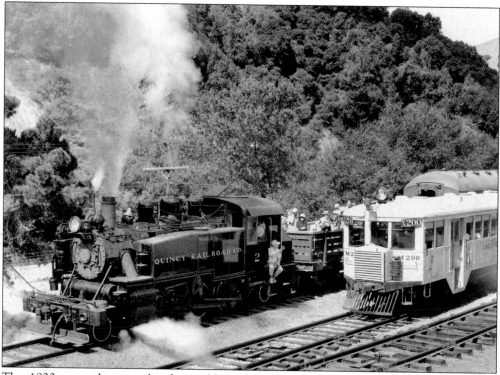

The 1920s turned out to be the "golden age" of new railway equipment for both steam locomotives and passenger cars. From this era, Quincy RR No. 2, dating back to 1924, and the M200 to 1926, were both retired by their respective railroads in the 1960s. Saved from being scrapped, they were acquired for preservation and remain active to this day on the Niles Canyon Railway. (Courtesy of Alan Frank.)

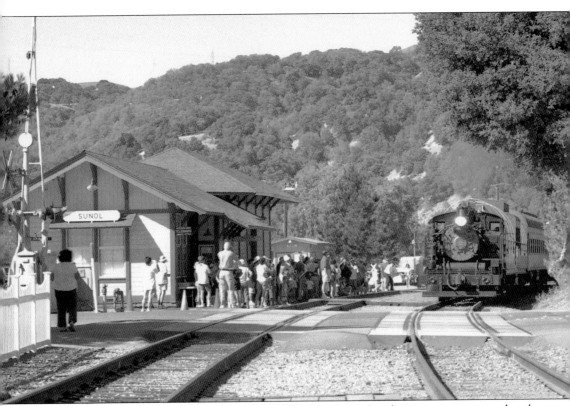

The morning train arrives at Sunol on a typical summer Sunday, as passengers gather by the station to get acquainted with the steam engine before boarding the train. (Courtesy of Alan Frank.)

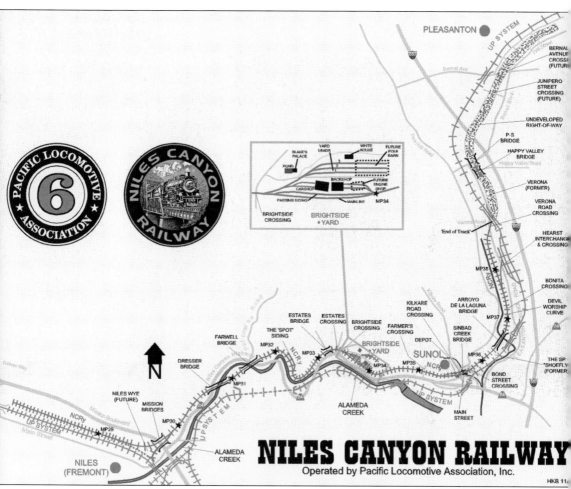

Pictured is a route map of Niles Canyon Railway (ex-Southern Pacific) and Union Pacific Railroad (ex-Western Pacific). (Map by Henry Baum and Jim Noble.)

Journal oil is checked and brought up to the proper level by Brakeman Phil Gresho before the train leaves the yard. Servicing the train includes cleaning the windows and sweeping the floor. Next the engine is coupled on, air pressure is built up, and brakes are checked. Then it is time to head for the station. (Author's photo.)

Passengers pick up tickets at the depot before boarding the train. There is no charge to ride the regular Sunday trains, making the Niles Canyon Railway a rather unusual operating museum. However, ticket agents Donna Alexander, Al McCracken, and Al Reynolds are pleased to suggest and accept donations, as every cent collected goes to keep this 100-percent volunteer rail museum operating. (Author's photo.)

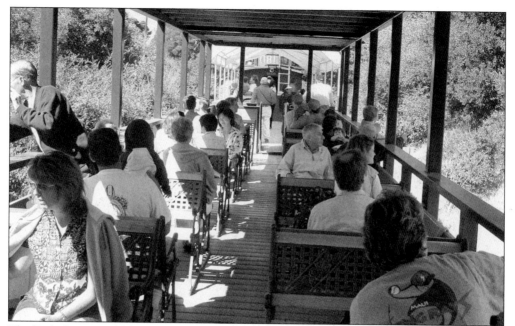

The Park Car started life as a 1940s flatcar before the Niles Canyon Car Department converted it into an open-air excursion car. It joins several other open sightseeing cars, which are popular even during the winter season. (Author's photo.)

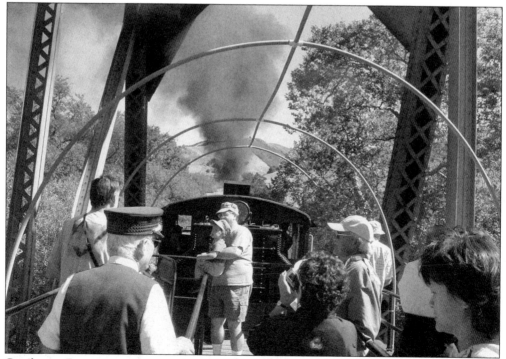

Conductor Doug Campbell answers question about the vintage steam train. The sightseeing car *K.C. Bones* features an open observation section at each end, allowing passengers to closely observe the steam or diesel locomotives and their engine crew in action. (Author's photo.)

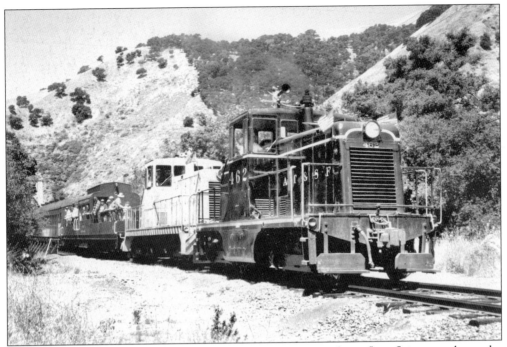

Continuing a railroad tradition, a holiday excursion train with its flags flying growls up the canyon with a load of passengers heading for a Fourth of July picnic at the Sunol Depot Gardens. (Courtesy of Johnathon Kruger.)

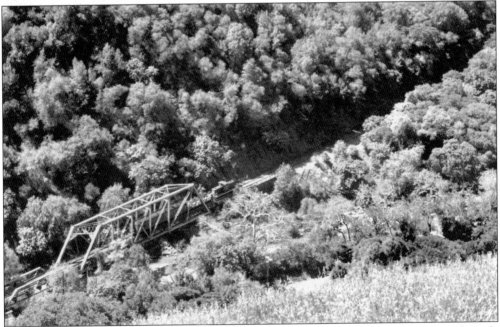

Deep in Niles Canyon and looking like a toy, a summertime Sunday train crosses Alameda Creek for the second time as it curves its way toward Sunol. This is the Farwell Bridge. Tree-shaded Joyland Park was located between the tracks and the creek on the right, while Fern Brook Park was at the left end of the bridge. (Courtesy of Alan Siegwarth .)

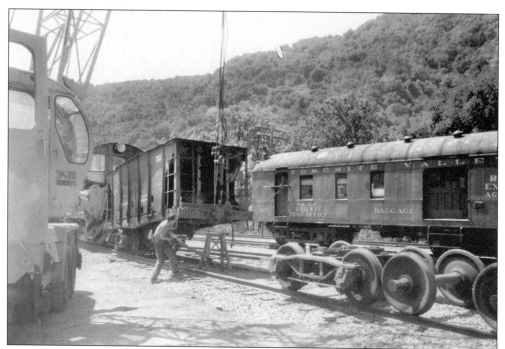

A simple term like "routine maintenance" has a different meaning when the equipment to be worked on can weigh in excess of 150 tons. Alan Siegwarth is in the middle of changing out a flat wheel on a Sierra Railroad "blackjack" hopper car, which weighs a mere 30 tons or so. (Courtesy of Johnathon Kruger.)

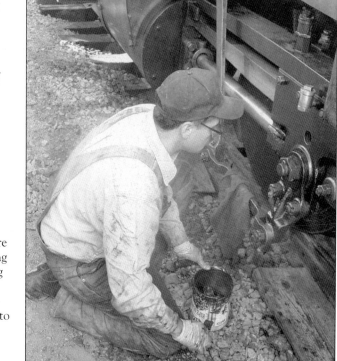

Maintenance and servicing are critical components of keeping vintage equipment in running condition. Hostler Dan Loyola lubricates the steam locomotive's valve gear prior to its starting a day's work of pulling trains. (Author's photo.)

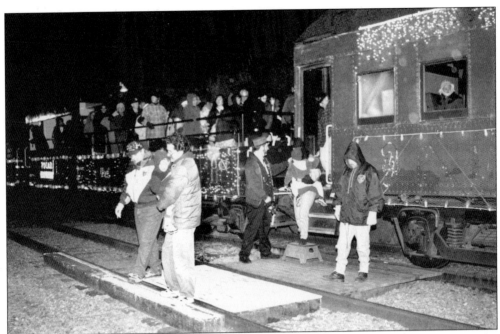

Once upon a time, a few Christmas lights were put on the exterior of a Niles Canyon train by museum General Manager Dexter Day to add a little cheer to a Members' Holiday Special. It made a nice sight as the train curved through the dark canyon. The following year, more lights were added, and the public, seeing the lighted train pass by, asked if they could climb aboard. Thus, America's first Christmas Train was born. (Courtesy of Jim Swofford.)

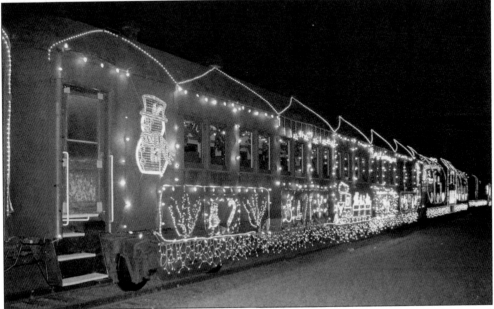

Over the years, more lights and decorations were added each season, and more people wanted to ride the train. The "Train of Lights" now glows brightly with over 60,000 lights on 12 cars and 2 engines. Over 10,000 holiday passengers ride the trains during the three weeks prior to Christmas, and it remains the most decorated train in America. (Courtesy of Stan Bringer.)

Five

HERITAGE LOCOMOTIVES
VINTAGE STEAM AND DIESEL

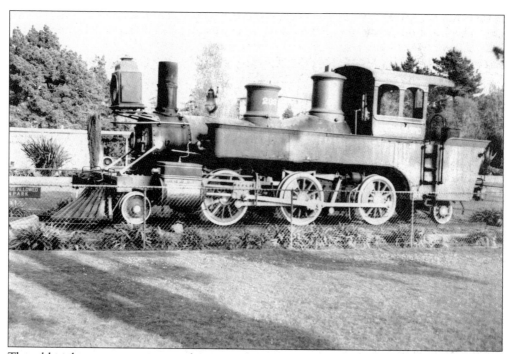

The oldest locomotive to grace the museum's Niles Canyon rails is No. 233, built by the Central Pacific in January of 1882 in their Sacramento Shops. Given to the Pacific Locomotive Association by the City of Oakland, this locomotive was considered too historic for operation and was traded to the California State Railroad Museum in Sacramento for preservation. (Author's photo.)

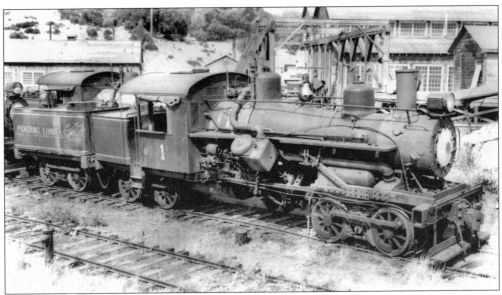

Pickering Lumber No. 1 is an 85-ton, 3-truck Heisler built in 1913. After a long career in logging service, this engine was placed on display at Monterey's Cannery Row. Rescued from rusting away in the salt air, No. 1 was donated to the Pacific Locomotive Association's collection of vintage locomotives and cars. (Tom Gray photo; courtesy of Doug Richter collection.)

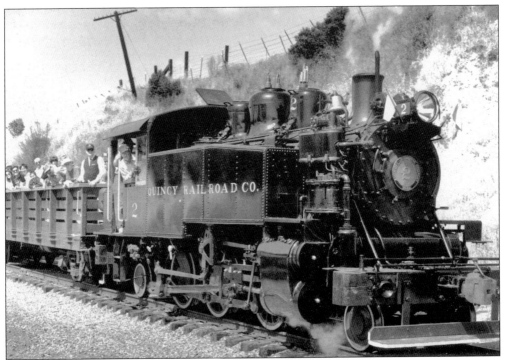

Quincy RR No. 2 regularly powers trains in the canyon. An Alco product of 1924, this 2-6-2T weighs a mere 55 tons, all of which was needed to push loads of lumber up the 5 percent grade from Quincy to Quincy Junction, near Portola, to connect with Western Pacific's Feather River Route mainline. (Courtesy of Alan Frank.)

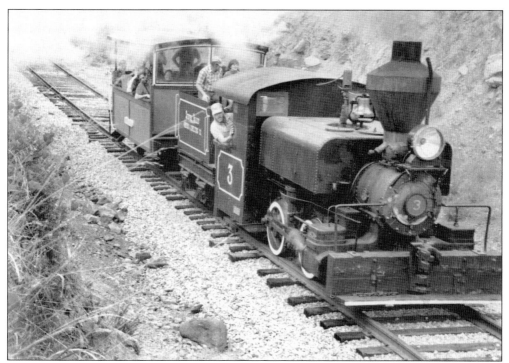

Steptoe Valley Mining No. 3 is the smallest locomotive of the collection at 17 tons. This 0-4-0T was built by Porter in 1913 and joined the collection through the courtesy of a Pacific Locomotive Association member who purchased the engine and then donated it. A new boiler will replace the original when the engine is rebuilt as No. 301. (Author's photo.)

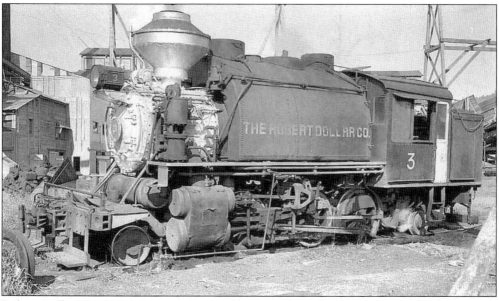

Robert Dollar No. 3 is the newest steam addition to the collection. Donated by the Western Railway Museum, this 1927 Alco 2-6-2T engine, sporting a balloon smokestack, has the honor of being the last wood-burning locomotive made in America. Later converted to burn oil, this engine will be in service along with Quincy RR No. 2. (Courtesy of Doug Richter collection.)

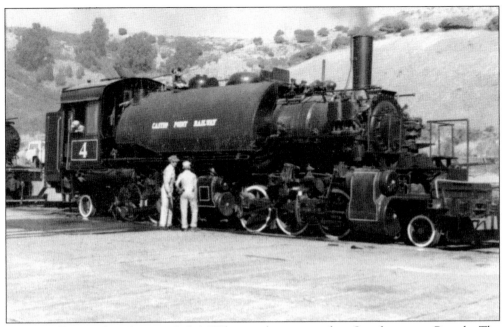

Clover Valley Lumber No. 4 is a 2-6-6-2T logging locomotive from Loyalton, near Portola. The simple, articulated design combines two engines under one boiler. Steam is first used in the rear engine and then passed to the forward engine to be used again. Baldwin built this powerful 110-ton locomotive in 1924. (Courtesy of Paul Hollidge.)

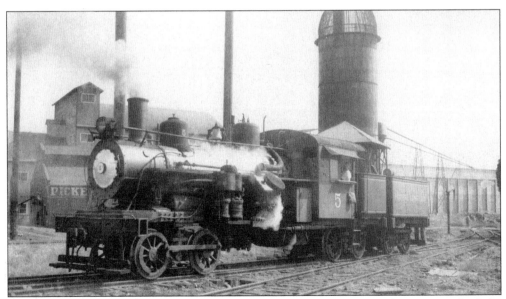

Pickering Lumber No. 5 and its sister No. 1 are both 3-truck, 85-ton locomotives built by Heisler. All 12 wheels are powered by a center drive shaft connected to two cylinders in a "V" configuration. They are designed to pull heavy loads up steep grades and around sharp curves on poor track with speed limited to about 20 mph. (Author's photo.)

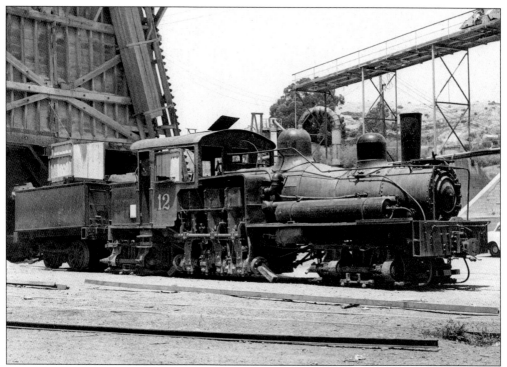

Pickering Lumber No. 12 is the oldest 3-truck Shay in existence. Built by Lima Locomotive Works in 1903 for service on Sierra Railway's lines from Jamestown to Angels Camp and Tuolumne, the No. 12 is still in good condition and awaits a return to operation on the Niles Canyon Railway. (Author's photo.)

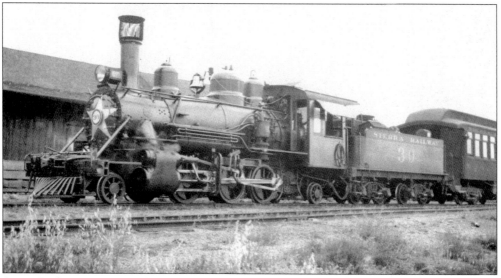

Sierra Railway No. 30 replaced No. 12 when received from Baldwin in 1922. Weighing 50 tons, 2-6-2 No. 30 was sold to Howard Terminal Railway and converted to tank engine No. 6. Purchased by the Pacific Locomotive Association in 1962, No. 6 became the first piece of the collection and the symbol of the association with its original six founding members. (Courtesy of Doug Richter collection.)

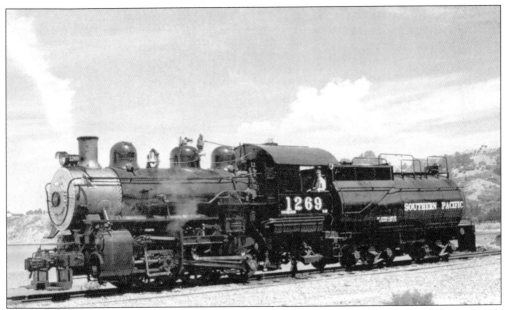

The Southern Pacific Shops in Sacramento built Southern Pacific No. 1269, a 76-ton 0-6-0, in 1921. Retired by the railroad in 1957, the engine was displayed at a Richmond park before being given to the Pacific Locomotive Association. After restoration, the 1269 ran on the association's Castro Point Railway and on California State Railroad Museum's line at Sacramento. (Courtesy of Pacific Locomotive Association.)

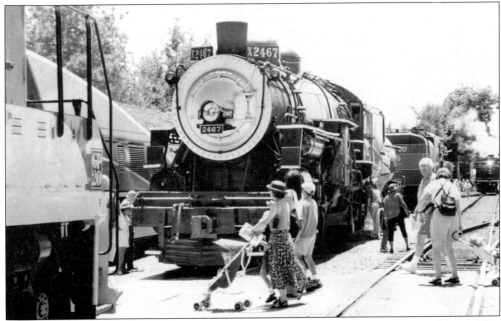

Southern Pacific No. 2467 is a classic 4-6-2 that was turned out in 1921 by Baldwin. This 150-ton engine, owned by the City of Oakland and displayed at Harrison Park since 1956, was rebuilt by Pacific Locomotive Association and run to CSRM's Railfair '99 celebration at Sacramento. Today, the 2467 is prominently featured in the state museum's roundhouse display. (Author's photo.)

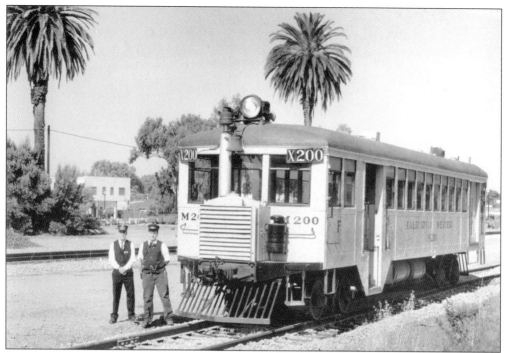

California Western M200, the only railcar built by Skagit Iron Works of Sedro Woolley, Washington, has been running every year since 1926. One of the famous "Skunks," the M200 was declared surplus and about to be scrapped when the Pacific Locomotive Association purchased the car from the California Western. (Courtesy of Alan Frank.)

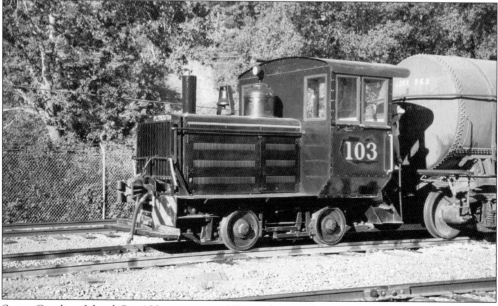

Santa Catalina Island Co. 103 was new in 1929 and assisted in the construction of Long Beach and Los Angeles harbors, as well as the Shasta Dam. Built by Plymouth Locomotive Works, the 10-ton "Dinky" is now the *Roundhouse Goat*, switching engines and cars around the Brightside Yard. (Author's photo.)

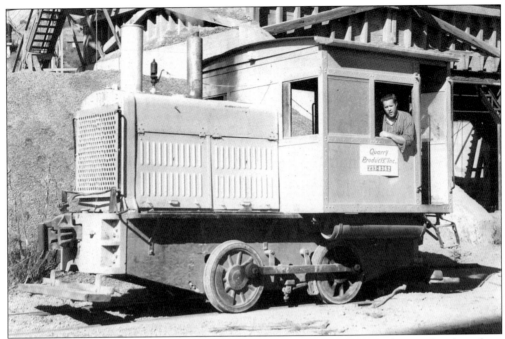

Blake Brothers 1 is a gas-mechanical 20-ton industrial locomotive, complete with side rods to power all 4 wheels. Made by Whitcomb in 1925, this little engine was a backup for their two-truck Heisler, switching cars on the Blake Brothers/Quarry Products line in Richmond, which was built as the Castro Point Railway. (Courtesy of George Childs collection.)

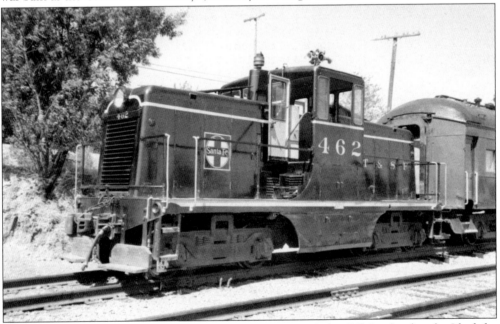

Atchison, Topeka & Santa Fe 462 is a 1953 "44-tonner," the DC-3 of railroads. Ideal for limited-duty switching or for use on light-rail track, these General Electric engines were very economical to operate (some with a one-man crew), serving a variety of mainline and shortline railroads. A few remain in service today. (Author's photo.)

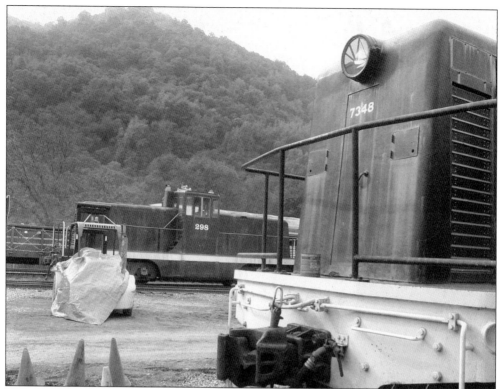

U.S.Army 298 & U.S. Navy 7348 are both center cab General Electrics, a 1945-built 80-tonner and a 1942-built 65-tonner respectively. Both were Oakland-based engines and acquired through military surplus. They powered nearly all Niles Canyon Railway diesel trains from the 1980s until 2002, when Southern Pacific 1423 arrived. (Author's photo.)

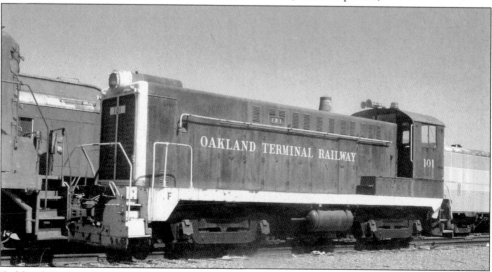

Oakland Terminal Railway 101 worked the industries of Oakland for 41 years. Santa Fe and Southern Pacific jointly owned the railroad, with each owner taking control for alternating five-year periods. A Baldwin product of 1948, No. 101 was rated at 1,000 horsepower, and retired in 1989. (Author's photo.)

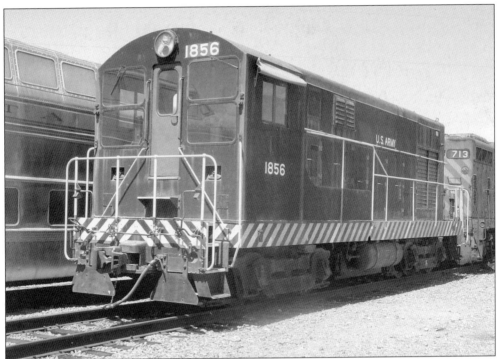

U.S. Army 1856 is a 1,000-horsepower Fairbanks-Morse switcher built in 1953. Fairbanks-Morse sold a variety of first-generation diesel locomotives, but never achieved the volume they desired. Their powerful *Trainmaster* was the only diesel that matched the performance of steam engines on Southern Pacific's demanding peninsula commute trains. (Author's photo.)

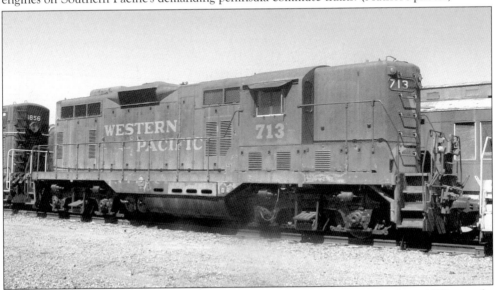

Western Pacific 713, a General Motors EMD 1,500-horsepower GP-7 built in 1953, weighs 125 tons, and was often found hauling freights through Niles Canyon. Retired by the railroad in 1983, the 713 was donated by Western Pacific to the Pacific Locomotive Association for preservation the following year. The green with orange lettering was Western Pacific's final paint scheme. (Author's photo.)

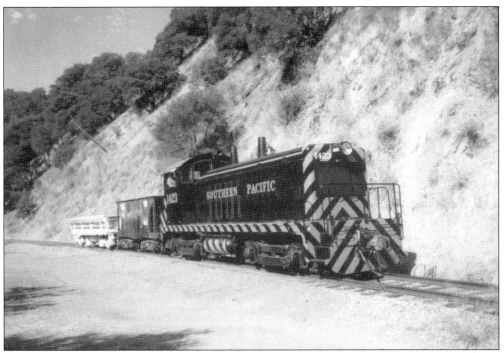

Southern Pacific 1423 (a.k.a. 1951 and 1335), a 110-ton NW-2 switcher dating from 1949, represents General Motors ElectroMotive Division, the most popular of the diesel builders. The 1423 went to Richmond's Parr Terminal Railroad, who donated the engine for use at Niles Canyon in 2002. (Courtesy of Johnathon Kruger.)

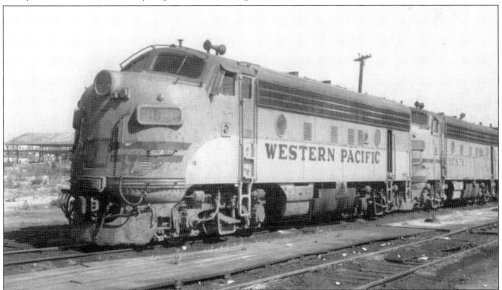

Western Pacific 918-D is a classic EMD F-7 A-unit built in 1950 and weighing 124 tons. The F-7 was one of the most popular diesel models produced during the early 1950s. At 1,500 horsepower, the 918-D was made to haul freights at 65 mph, and remained in service until 1981, becoming one of the last of it's type to serve the railroad. (Pacific Locomotive Association collection.)

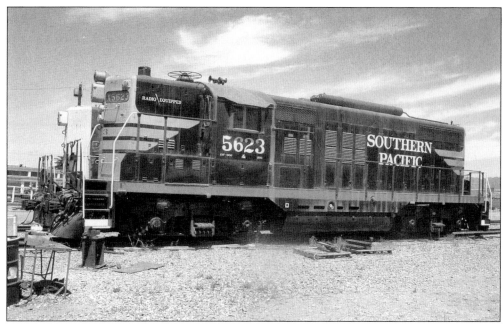

Southern Pacific 5623 (a.k.a. 3005 and 3189) is a 130-ton, 1,750-horsepower, Geep-9 *Torpedo Boat* that pulled both freight and passenger trains. Having dual controls to allow the engineer to run facing forward in either direction was designated by the orange and silver wings on both ends of its Black Widow paint. (Author's photo.)

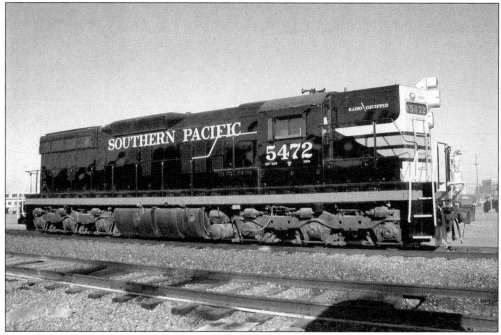

Southern Pacific 5472 (a.k.a. 3946 and 4423) is an EMD product of 1956. At 180 tons, this 1,750-horsepower SD-9 was one of the "Cadillacs" of the rails due to the good ride provided by the six-wheel trucks, a fact that made them popular on light rail and "not-so-good" track found on branch lines and Northwestern Pacific's line to Eureka. (Courtesy of Howard Wise.)

Six

BEFORE NILES CANYON

EQUIPMENT HISTORY

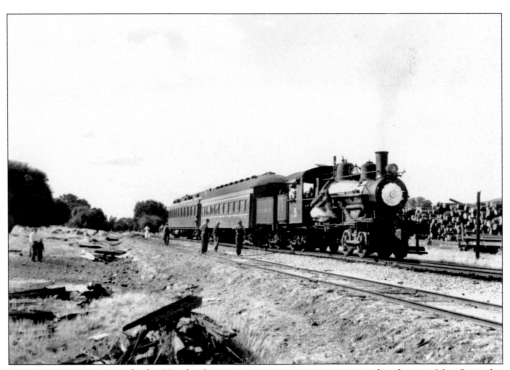

It was not common to find a Heisler locomotive on a passenger train, but here is No. 5, in the middle of Pickering's mill at Standard, ready to depart with a passenger train. The reason, of course, is a railfan trip in 1955. Number 5 has the honors on joint trackage to Ralph, where a Sierra Railroad engine takes over to Tuolumne. (Courtesy of Buell Edison.)

In this 1940 scene, Quincy No. 2 just climbed the five percent grade up to the Western Pacific interchange at Quincy Junction with an outbound mixed freight. The caboose is stopped at the Western Pacific depot for the convenience of the crew. Western Pacific's Oakland/Salt Lake City mainline is the middle set of tracks. (Will Whittaker photo; courtesy of Johnathan Kruger collection.)

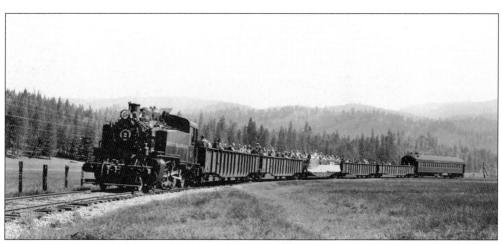

Quincy Railroad hosted a variety of excursion trains over the years, always with No. 2 in the starring role. Most passenger specials were in conjunction with a Western Pacific excursion train from the San Francisco Bay Area, as were the guests on this train traveling across the meadows to the town of Quincy in 1950. (Will Whitaker photo; Pacific Locomotive Association collection.)

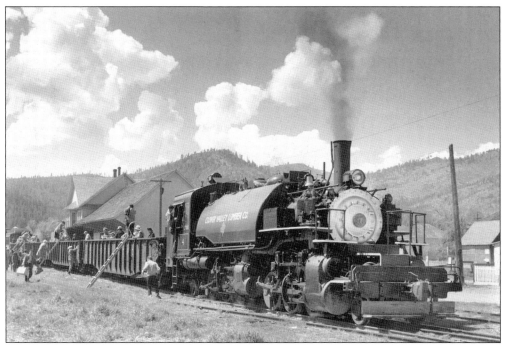

A little further east on the Western Pacific, past Portola, was the Clover Valley Lumber Company and their railroad to Loyalton, home of logging Mallet (pronounced "malley") 2-6-6-2T No. 4. Also at the request of Western Pacific, this line hosted occasional railfan specials. Note the deluxe boarding stairs on this train. (John Illman photo; courtesy of Henry Bender collection.)

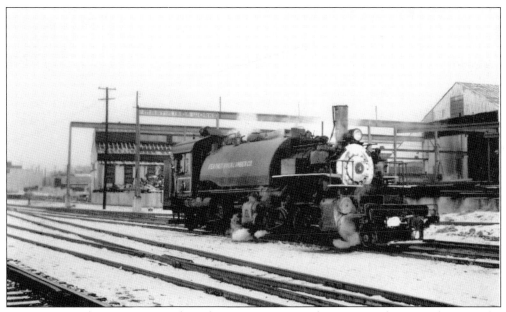

On a winter's day No. 4 is on the siding in Reno, Nevada, en route from Loyalton via the Western Pacific to Sparks for servicing by the Southern Pacific. Then after a swing on the turntable, the Mallet will head west to a new owner, Tahoe Timber at Verdi, to become a stationary boiler until rescued by the Pacific Locomotive Association for preservation.

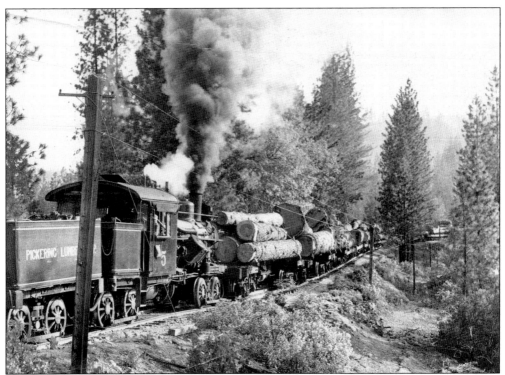

California's vast lumber industry created many shortline and logging railroads, such as the Sugar Pine Railway, predecessor to the Pickering. Here three-truck Heisler No. 5, with a trainload of logs heading for the mill at Standard, is seen near Twain Harte. Pickering had several Heislers as well as Shays. (Courtesy of M. Reusser collection.)

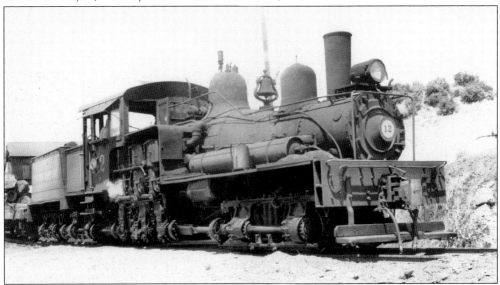

Pickering No. 12 switches the mill at Standard in June of 1955. Designed by Ephraim Shay, power is provided by three cylinders connected to a flexible drive shaft that runs to each axle, all accessible on the engineer's side of the locomotive for easy maintenance. Shays were the preferred "woods engine" on most logging railroads. (Author's photo.)

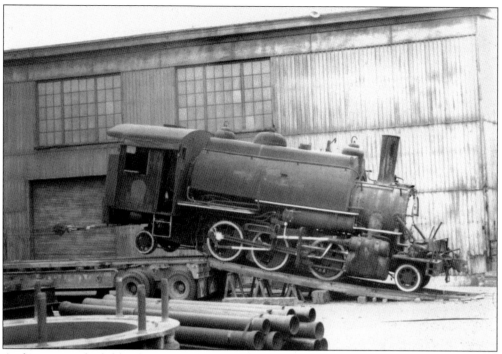

At first, it may look like the scene of an accident. But in reality, Howard Terminal No. 6 is in the process of beng loaded onto a flatbed trailer. The Baldwin 2-6-2T is about to leave the piers of Howard Terminal for a new life of hauling passengers on the Castro Point Railway. (Courtesy of Don Hansen.)

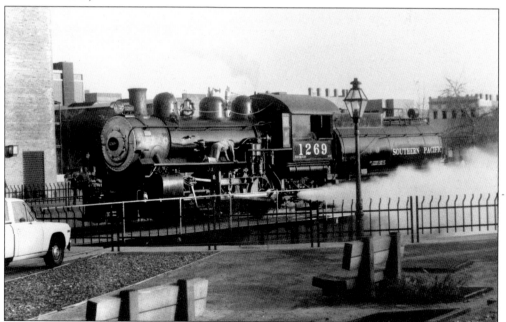

Back in Sacramento where she was "born," Southern Pacific 1269 gets swung on California State Railroad Museum's turntable while visiting Railfair '89. Southern Pacific's Sacramento Shops built this 76-ton 0-6-0 from the rails up in 1921. (Author's photo.)

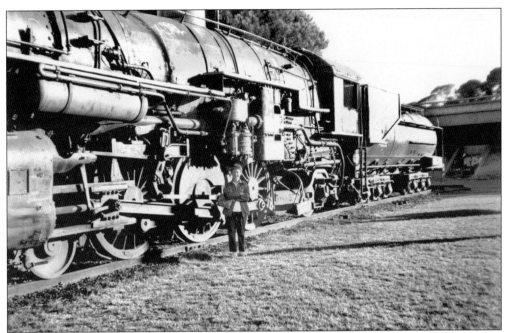

One of the largest restoration projects completed by members of the Pacific Locomotive Association is Southern Pacific 4-6-2 No. 2467, which was donated to the City of Oakland and placed on display at Harrison Park. Jenny Benner stands next to the 2467, demonstrating the impressive size of this classic Pacific locomotive. (Courtesy of Warren Benner.)

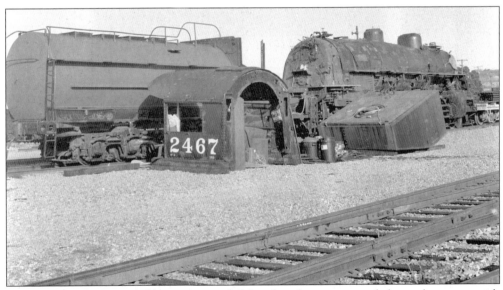

Work by volunteers, guided by professional railroad craftsmen, proceeded at a slow pace, with week-to-week progress hard to identify. The engine's boiler, firebox, flues, tubes, and tubesheets were thoroughly cleaned, checked, and repaired, as was the dynamo, air pump, throttle, etc. (Courtesy of Alan Frank.)

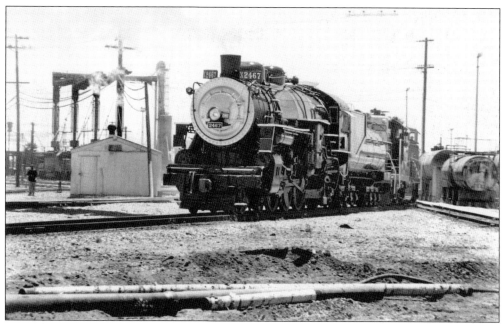

After nearly nine years of rebuilding, and a few trips on a short test track, the 2467 proudly returns to familiar rails in the Oakland Yard, ready to try the mainline to Sacramento, with Geep 5623 and a Santa Fe caboose in tow. It has been 42 years since this engine has traveled the main, and she does well. (Courtesy of Warren Benner.)

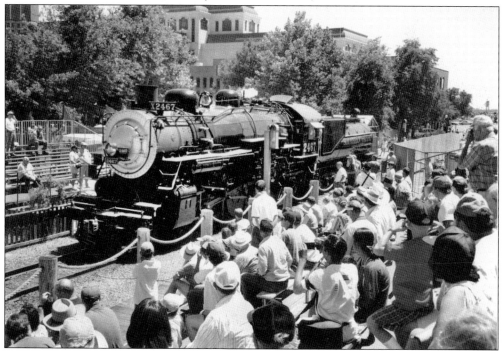

The appearance of 2467 at Railfair '99 was a surprise to everyone, as rumor had it that the engine would not be ready in time. The audience was delighted when the *Pacific* passed the review stands, looking like a brand new locomotive. (Author's photo.)

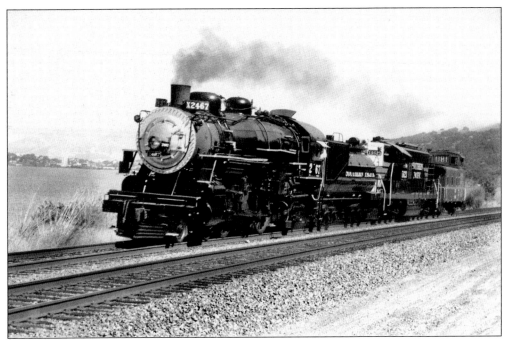

Passing Martinez and heading home along the Carquinez Straits on a summer day of 1999, the 2467 caused a surprised expression on many faces along the way. While most of the trip to Oakland was made at a leisurely pace of 35 mph, occasional sprints closer to 70 mph were made to check the rod motion. (Author's photo.)

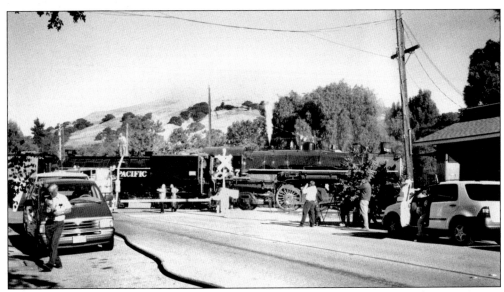

On another adventure the following year, 2467 stops at the post office on Sunol's Main Street. The nearby fire department provided a drink of water before the *Pacific* started to climb Altamont Pass on the Union Pacific line. Her last run was doubleheading with 2472 at the Golden Gate Railroad Museum in San Francisco. (Author's photo.)

The elegant 5623 was another star at Railfair '99, resplendent in Southern Pacific's colorful Black Widow scheme and operated at the hands of her restorer, Howard Wise. The 1955-built 5623 still worked as the backup locomotive for Oakland Terminal's lone diesel until January 1, 2005. (Author's photo.)

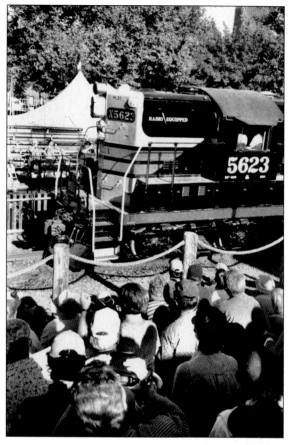

The 5623, numbered 3189 in 1981, heads a commute train of double-deck gallery cars down the peninsula. This line was originally built as the San Francisco & San Jose Railway in 1864, and later became part of the Southern Pacific. CalTrain became owner of the line in 1992, with operating crews provided by Amtrak. (Courtesy of Henry Bender.)

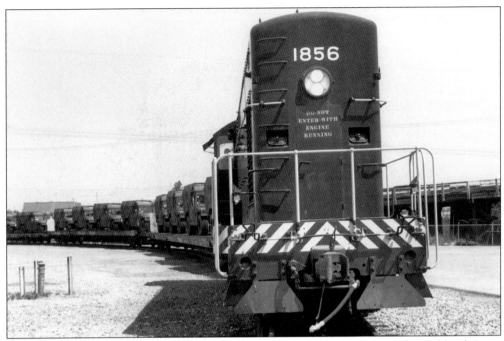

The Army's Fairbanks-Morse No. 1856 switches a load of vehicles around the Oakland Army Terminal. In the background is the Interurban Electric Railway's wooden trestle leading to the second story of the once-busy Sixteenth Street Station. (Bill Wullenjohn photo; Pacific Locomotive Association collection.)

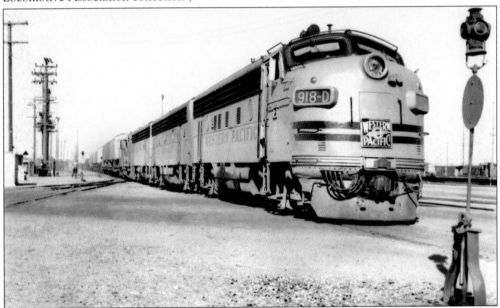

The date was April 23, 1966, as Western Pacific's GGM (Golden Gate Merchandise) is ready to depart Oakland with the lead unit, No. 918-D, in control. Already 16 years old, this EMD F-7A unit would continue to earn revenue for the Western Pacific until retirement in January of 1982, after which the veteran was donated to Pacific Locomotive Association for preservation. (Courtesy of Virgil Staff.)

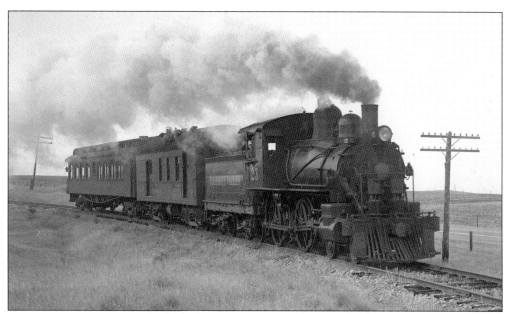

The legendary Yosemite Valley Railway ran from Merced to El Portal until 1945. All of their passenger cars were wooden, with the one exception being the all-steel Baggage Post Office No. 107, seen here between 4-4-0 No. 23 and Yosemite Valley's classic observation. Both cars still exist, with the 107 now in the canyon. (Robert Searle photo; Pacific Locomotive Association collection.)

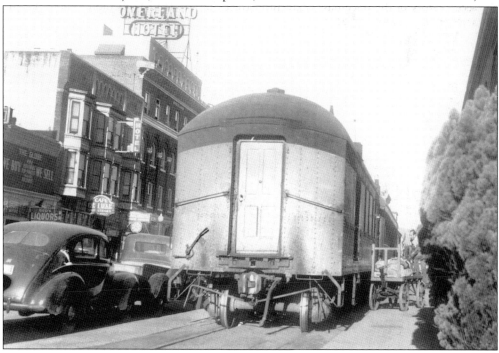

When the Yosemite Valley shut down, the 107 was sold to the equally legendary Virginia & Truckee for their Reno to Carson City and Minden trains. Mail and luggage are being loaded at Reno's Southern Pacific station into Virginia & Truckee's only steel car. Their tracks were at the front of the depot, with Southern Pacific tracks on the far side. (Eldon Lucy photo; courtesy of the author.)

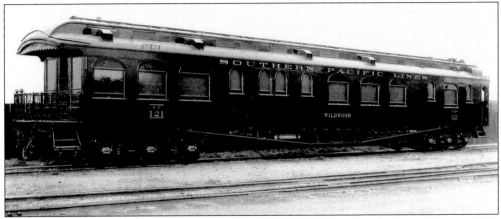

The Southern Pacific Business Car *Western* was donated to Oakland for display at Harrison Park with No. 2467. Built by Pullman in 1903 as a wooden car on a steel frame, car 121 was given the name *Wildwood*. When Southern Pacific rebuilt the car with air conditioning and steel siding, it became the *Western*. This car was selected to carry the body of President Harding through Niles Canyon in 1923. (Pullman photo; Pacific Locomotive Association collection.)

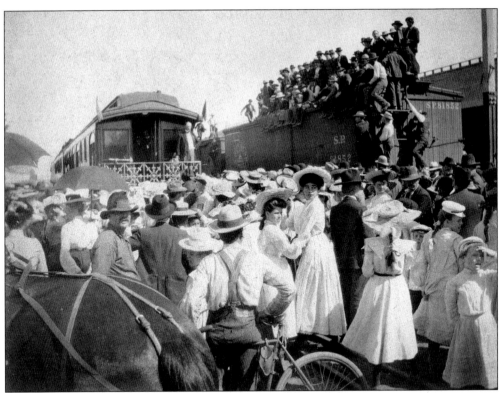

President Taft, seeking reelection, speaks to the crowd at Pleasanton from the rear platform of the *Western* as he whistle-stops through California. Now in Niles Canyon, the *Western* joins other heritage passenger cars preserved for the future. The car is undergoing extensive repairs due to damage experienced while on display at Oakland's Harrison Park. (Courtesy of the Amador-Livermore Historical Society.)

Seven

RAILROAD STRUCTURES

DEPOTS, BRIDGES, AND STATIONS

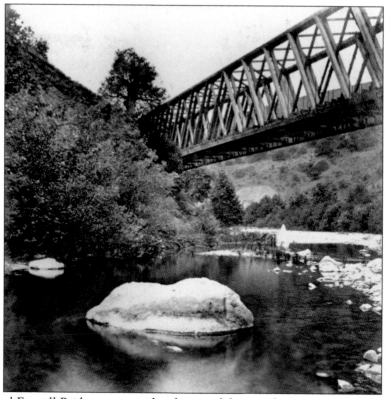

The original Farwell Bridge was considered state of the art when constructed in 1866 by the first Western Pacific Railroad. Three years later the Central Pacific put a cover on it. Heavily engineered for railroad use, the bridge piers are still used today. (Courtesy of California Pioneers Collection.)

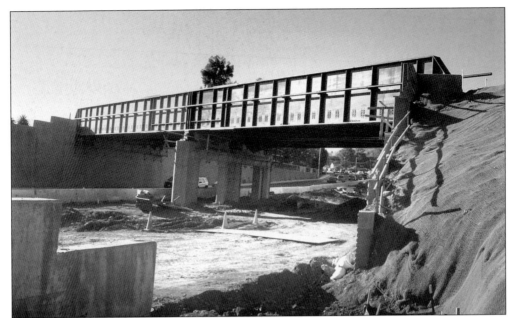

Of the four major bridges presently on the Niles Canyon Railway, the first to be crossed when leaving Niles is the newest, installed in 2004, to allow additional traffic lanes on Mission Boulevard. The previous girder bridges at this location dated from another lane expansion during the 1930s. (Author's photo.)

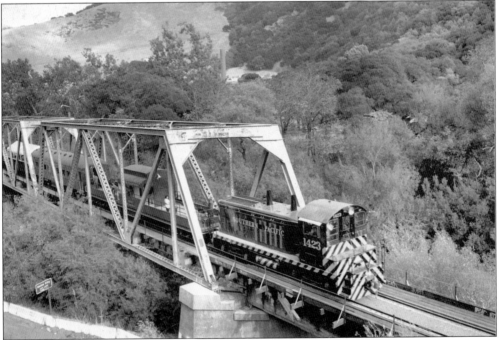

The next three bridges, originally of wooden construction from the 1860s, were replaced with steel bridges around the turn of the century. The second bridge to be crossed is Dresser, a riveted through truss bridge built in 1906 by the American Bridge Company, crossing Highway 84 and Alameda Creek. (Courtesy of Alan Siegwarth .)

The original stone abutments and piers, dating from the 1860s, were used to support the three steel bridges, which they do to this day. While upgrades have been made over the years, the original piers could well represent the West's oldest example of railroad engineering in use today. (Courtesy of Alan Frank.)

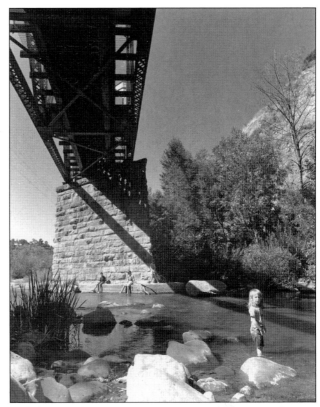

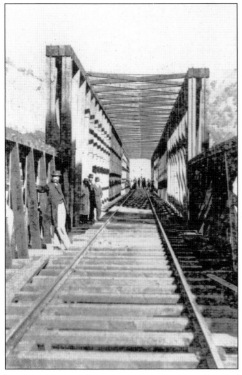

About a mile further east is Farwell Bridge, with a second crossing of Highway 84 and Alameda Creek. In this 1866 photo, the original Western Pacific wooden bridge receives an official inspection, complete with a photographer. (Courtesy of Randy Hees collection.)

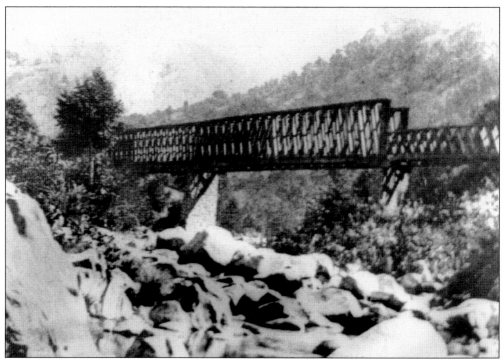

This photograph is of Farwell Bridge as viewed from Alameda Creek. This bridge was 488 feet long, consisting of three Howe Truss spans. It remained in use until 1896 when the wooden structure was replaced with a new steel bridge, due in part to the planned use of larger, heavier steam locomotives and trains. (Courtesy of Randy Hees collection.)

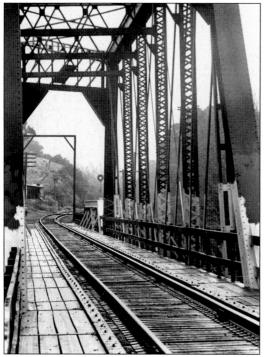

In this Southern Pacific-era look at the 1896 Farwell Bridge, a target signal light shows that the following block is clear. And while the warning telltales have been removed because brakemen are no longer allowed to walk on car roofs, the telltale frame remains. (Courtesy of Joe Ward.)

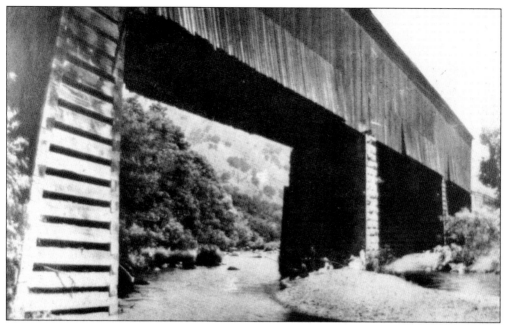

The fourth bridge is east of Sunol over the Arroyo de la Laguna. Originally built as a covered Howe Truss bridge in 1869 as part of Central Pacific's completion of the transcontinental railroad, it is 468 feet in length. The cover extended bridge life by protecting the wood from weather. (Courtesy of Museum of Local History, Fremont.)

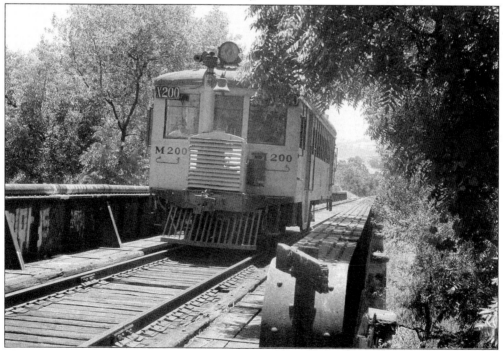

The wooden bridge was replaced in 1898 by the present Phoenix Bridge Co. girder design. On the occasion of the grand reopening of the bridge on Sunday, July 4, 2003, M200 provides passengers with a close inspection. (Author's photo.)

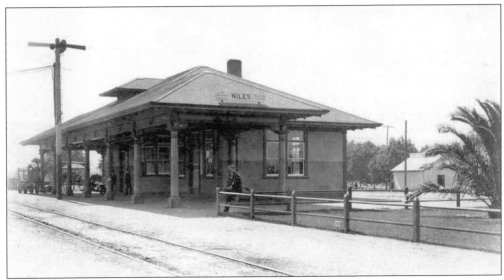

The Niles depot (mp 29.2) was built in 1901 of redwood from the Santa Cruz mountains and milled in Southern Pacific sawmills. Scheduled passenger train service ended on January 25, 1941, and the freight office closed in 1974. The City of Fremont purchased the building in 1981 and moved it a half-mile north on Mission Boulevard. (Courtesy of Erle Hanson.)

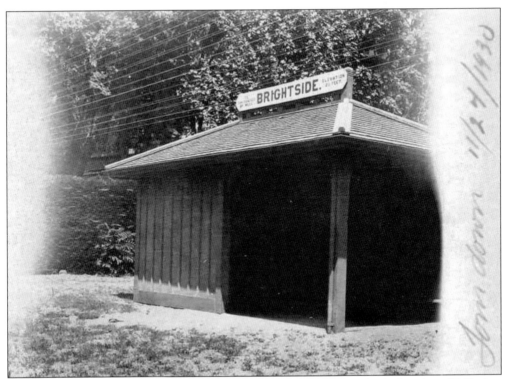

This is the only known photo of the small 9- by 18-foot Brightside shelter (mp 33.5) that protected passengers waiting for a train. After the "Picnic Specials" lost their popularity due in part to the stock market crash of 1929, the shelter was torn down in November of 1930. (Southern Pacific Collection; courtesy of Henry Bender.)

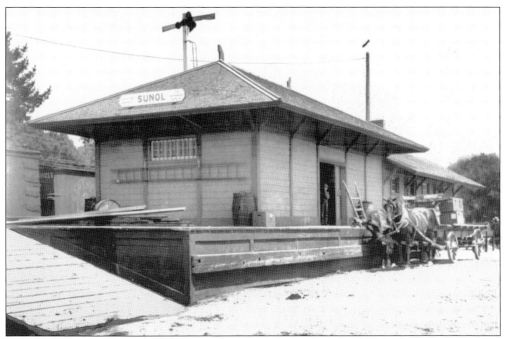

Sunol's 1884 depot (mp 35.6) was unchanged when Niles and Pleasanton had their original depots replaced around 1900. With the order boards at "stop," a freight train at the station and a horse and wagon waiting with freight, noontime activity is captured in this c. 1912 photo. The depot was closed in the 1930s. (Courtesy of Southern Pacific collection.)

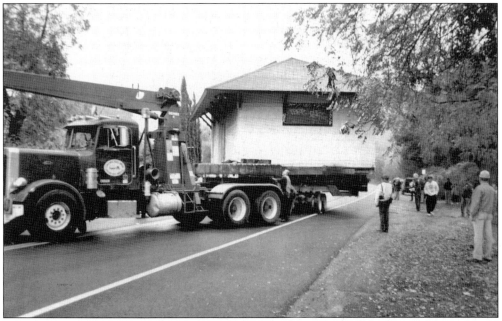

After passenger train service was discontinued on January 25, 1941, the Sunol depot was sold and moved a half-mile west that year to become a restaurant and later a home. Acquired by Alameda County Water District in 1992, the depot was returned to its Sunol location via Highway 84 on Sunday, November 22, 1998. (Courtesy of Warren Benner.)

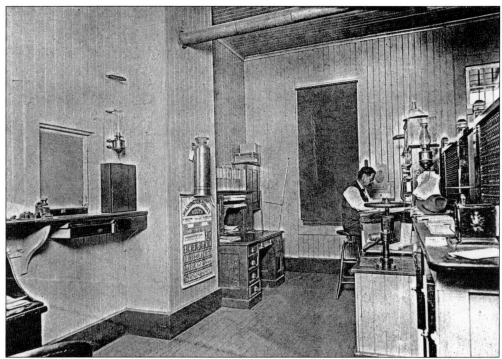

George Bayley, pictured here in 1913, was the only agent assigned to the Sunol depot. In this image the orderly passenger window on the left contrasts with the cluttered freight window on the right. A "station" is a location where a train may stop—perhaps nothing more than a sign— while a "depot" is a building. (Pacific Locomotive Association collection.)

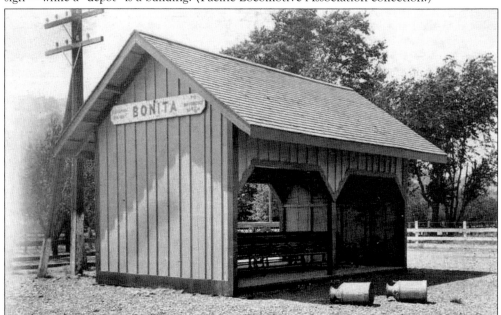

A small passenger shelter at Bonita (mp 37.2) was built 1.6 miles east of Sunol about 1901. It served the local dairy farmers (note the milk cans on the ground), and was a nearby picnic ground as well. The shelter was retired in March 1939. (Courtesy of Southern Pacific Collection.)

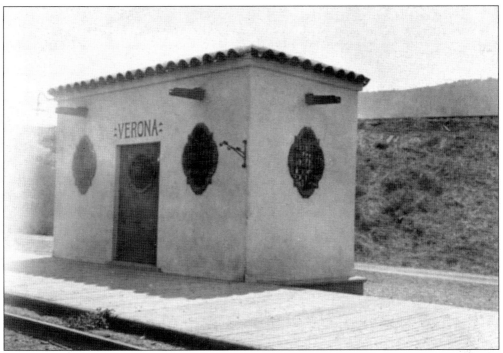

The privately owned Verona shelter (mp 38.4) was designed by Julia Morgan for Phoebe Apperson Hearst, mother of William Randolph Hearst, for guests visiting their nearby 92-room home, named *Hacienda del Pozo de Verona* for a stone wellhead that her son brought from Verona, Italy. This is now the site of Castlewood Country Club. (Courtesy of Southern Pacific Collection.)

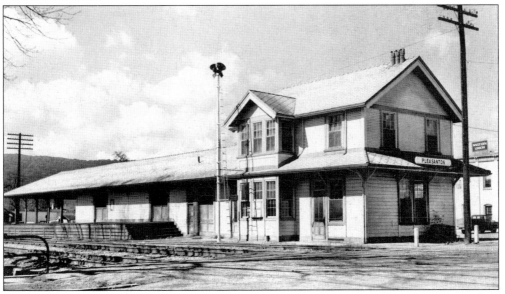

Pleasanton's depot (mp 40.9) opened in 1894. Only freight was handled after 1941 when passenger service ended. The depot closed in 1958, after which it was leased out to various businesses. A major restoration was completed in 1988. Today, the only details lacking are tracks and trains. (Will Whittaker photo; courtesy of Henry Bender collection.)

The Central Pacific freight shed at Niles was built by the Central Pacific in the early 1870s. Today it sits in the middle of downtown and is included in the plans to redevelop the Niles business area by the City of Fremont. (Author's photo.)

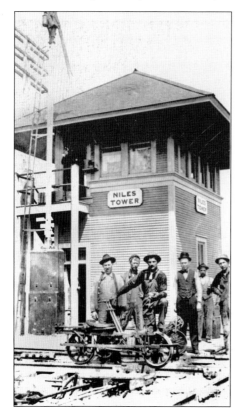

The track gang poses at Western Pacific's new Niles Tower, constructed in 1913 where the Western Pacific mainline crossed the Southern Pacific. The tower controlled all Southern Pacific and Western Pacific trains using this crossing. Modern technology eliminated the need for the tower in January 1986. It was destroyed by fire later that year. (Courtesy of Western Railway Museum collection.)

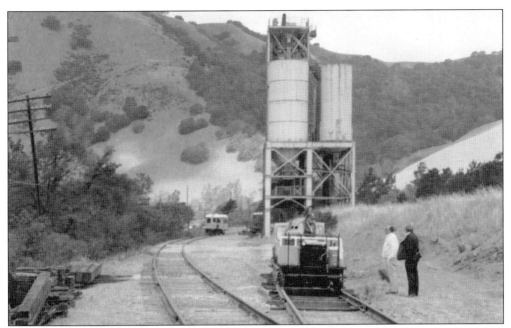

A view of the Brightside Yard in this 1988 image shows only the restored mainline and a switch leading toward Kaiser's abandoned Kailite tipple. Mike Bozzini and Dexter Day stand next to the speeder, with Charlie Blake sitting at the controls, waiting for the M200 to pass. (Courtesy of Warren Benner.)

With new siding, the converted tipple becomes not only a much-needed machine shop, but a two-stall engine house as well. All maintenance and restoration work on the Niles Canyon Railway's heritage railroad is accomplished by Pacific Locomotive Association members who volunteer their time and talent to making this operating museum grow. (Courtesy of the author.)

Brightside is the home base of the heritage railway. To accommodate the museum's collection of vintage trains, the area is prepared for the addition of yard tracks. The mainline is at the far left. (Author's photo.)

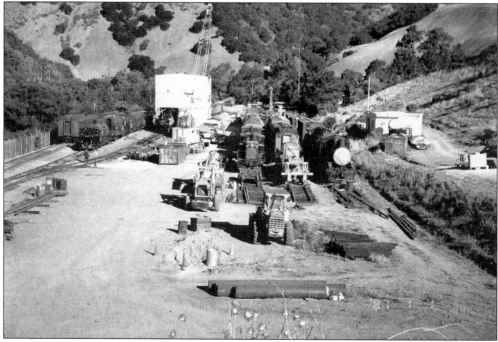

"Build it and they will come." As track is built, more equipment arrives by truck to fill the tracks. Missing from this picture are the larger locomotives and cars that were temporarily stored in Oakland and Fremont until a connection was made with Union Pacific, allowing a move to Niles Canyon by rail. (Author's photo.)

Eight

THE PACIFIC LOCOMOTIVE ASSOCIATION

A RAILROAD PRESERVATION SOCIETY

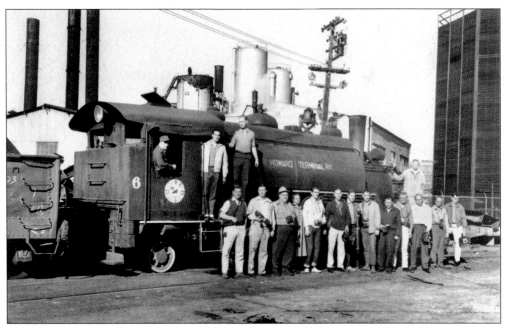

Six college students from the Peninsula formed the Pacific Locomotive Association in June of 1961, with the idea of keeping the steam era alive for all to see. Five of the six are in this photo. From left to right are first president Henry Luna (in cab door), Karl Koenig (on engine next to cab), Bart Gregg (white pants in middle), Tom Eikerenkotter (fourth from right), and Robert Field (far right). Not shown is C.G. Heimerdinger Jr., the sixth founding member. (Courtesy of Don Hansen.)

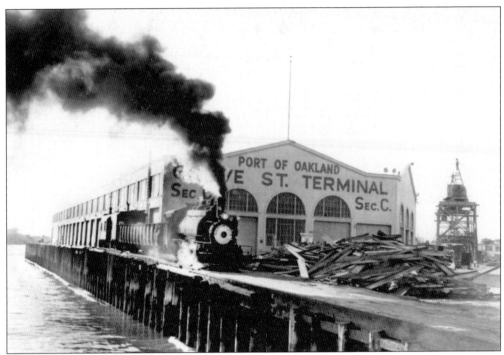

It started with a chartered train on the Howard Terminal Railway with 2-6-2T No. 6 and a borrowed Western Pacific bay-window caboose. The group would eventually buy the engine for $750 from the Howard brothers, with their stipulation that it never be scrapped, and thus began both the collection and the first of many unusual chartered trains. (Courtesy of Don Hansen.)

An old Heisler locomotive, with wheels buried in dirt from non-use, sat at Richmond's Blake Brothers Quarry. This was the second railroad to be visited by the group. The locomotive was fired up while the group dug out the tracks—their first experience with the line that was once named Castro Point Railway. (Author's photo.)

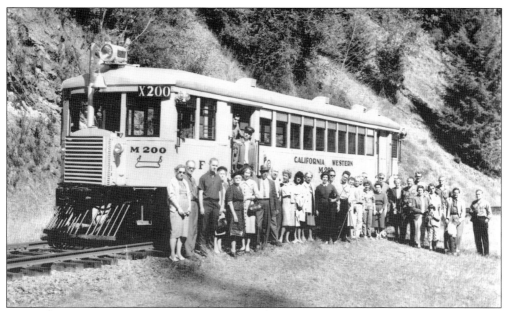

Two "fund-raising" trips aboard California Western's Skunk M200 were run in 1962, and the pubic responded. The $6.35 roundtrip fare included coffee and donuts. When the M200 was retired, the Pacific Locomotive Association was able to purchase the motorcar for scrap value, saving a unique piece of rail equipment for future generations to experience. (Courtesy of Don Hansen.)

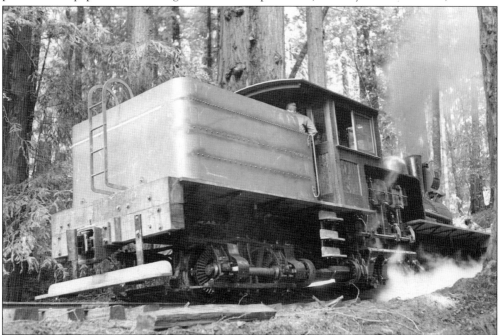

On occasion, the Pacific Locomotive Association sponsored a "first" rather than "last." On March 31, 1963, Roaring Camp & Big Trees was officially opened with speeches by the railroad's Norman Clark and the Pacific Locomotive Association's Henry Luna. The *Dixiana Shay* then came charging out from behind a redwood to provide rides for the 200-plus guests on the first revenue train. (Courtesy of Jim Wren.)

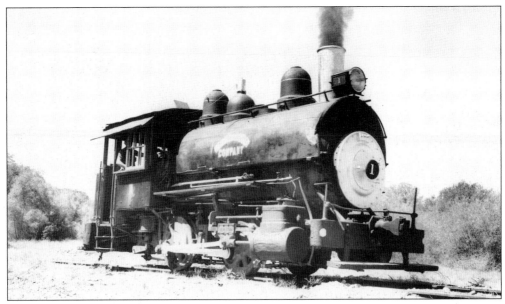

The friendly Henry J. Kaiser Company at Oroville had three little abandoned 0-4-0T locomotives once used in their quarry operation. A members' field trip was allowed to paint and letter the engines, and "fire them up" for photographs with the help of some cut up rubber tires down the stack, followed by a little gasoline and a lit match. (Author's photo.)

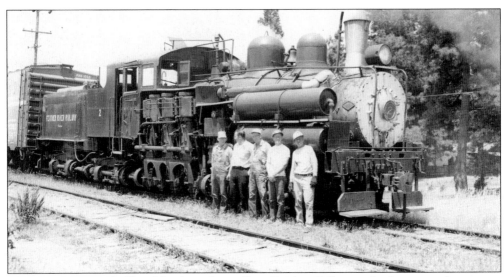

The crew poses with Shay No. 2 at the mill in Feather Falls, on the last run of steam on the Feather River Railway, May 21, 1966. The Pacific Locomotive Association chartered the engine, but riding was not allowed, so this field trip had members walking ahead of the train, recording the day's events on film. This engine is now at Railtown 1897. (Courtesy of the author.)

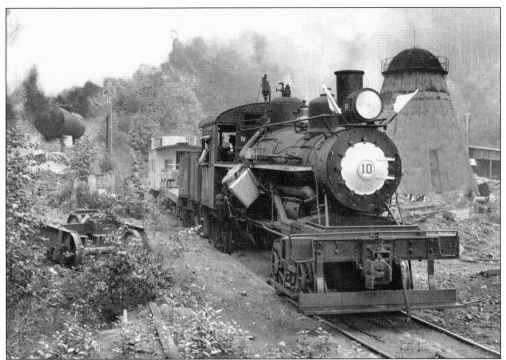

Another unique railroad was the Klamath & Hoppow Valley, above Eureka. Owner Gus Peterson invited the Pacific Locomotive Association to run the railroad on occasion. Pickering Heisler No. 10 was a favorite, due to its design, to run over poor track on steep grades. This line lasted only a few years. (Courtesy of Virgil Staff.)

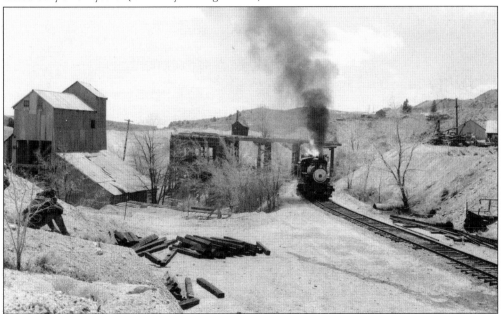

The fabled Virginia & Truckee, which once hauled Comstock silver and gold out of Virginia City, has hosted Pacific Locomotive Association excursions on various occasions with their newest locomotive, 2-8-0 No. 29, which came from the Longview, Portland & Northern.

Bill Harrah's transportation museum at Sparks included narrow-gauge Eureka & Palisades No. 7, which he had fired up for the Pacific Locomotive Association's visit. Everyone had the opportunity to run the engine over a short track, including Bill Harrah and his friend Red Skelton.

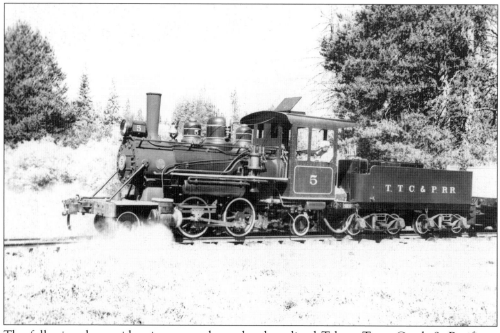

The following day, a side trip was made to the short-lived Tahoe, Trout Creek & Pacific, a narrow gauge line that had high hopes of providing mass transit for the Lake Tahoe basin—something that never came close to materializing. (Author's photo.)

Shortlines such as the Yreka Western provided spectacular moments with steam as this Pacific Locomotive Association special heads for a connection with the Southern Pacific at Montague. Engine No. 19, built for the McCloud River Railroad, remains on the YWRR. (Courtesy of Virgil Staff.)

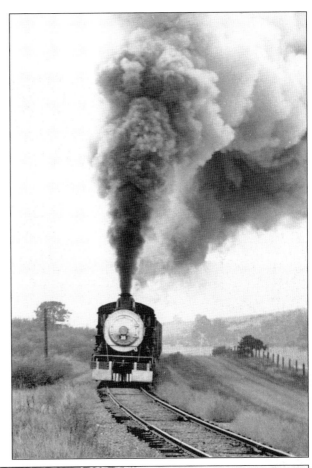

The Pacific Locomotive Association has developed an association with the McCloud that lasts to this day. Winter excursions, complete with snowplow, have become a tradition over the years. A variety of steam-powered freight, passenger, and mixed trains have operated for the Pacific Locomotive Association in all seasons with both 2-6-2 No. 25 and 2-8-2 No. 18. (Author's photo.)

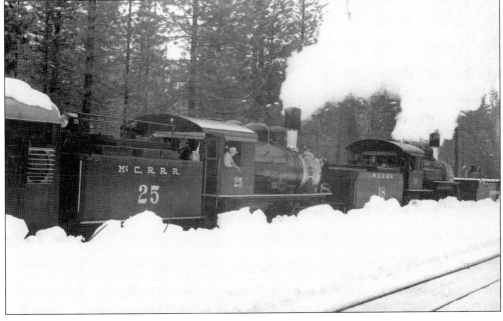

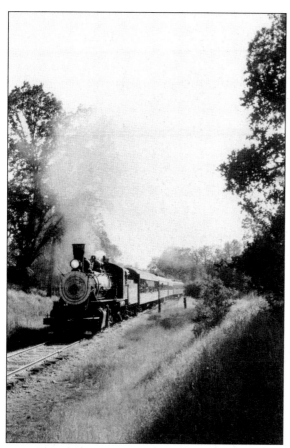

Heading west with a four-car Pacific Locomotive Association special is No. 34. A close relationship developed with Sierra Railroad when a Pacific Locomotive Association member became the first manager of Railtown 1897. Several members have been employed by the railroad over the years, and the entire Railtown complex was run by the association as concessionaire in 1983. (Author's photo.)

A rare triple-header was one feature of the Pacific Locomotive Association's 1971 "Labor Day Steam Spectacular." This three-day event included three different trains on Sierra Railroad, two narrow gauge trains on the Westside, and three full days of steam on Pickering's Sugar Pine Railway. It was the greatest steam train event ever held for the public in the Mother Lode country. (Author's photo.)

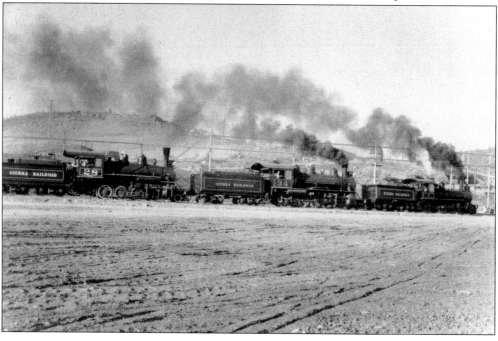

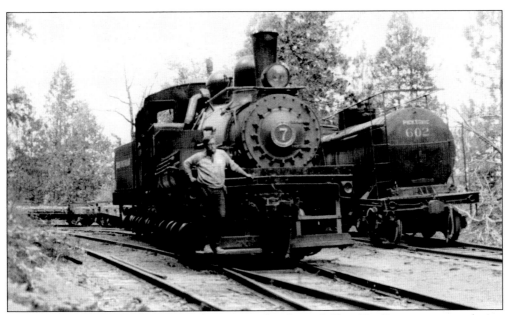

Pacific Locomotive Association members repaired Pickering's Shay No. 7 to running condition, built and painted an entire train out of logging flats, and cleaned years of pine needles off seven miles of track at the insistence of the forest service, just to run for the public during the three-day Steam Spectacular. It was a major effort, and was well done. (Courtesy of Brian Wise.)

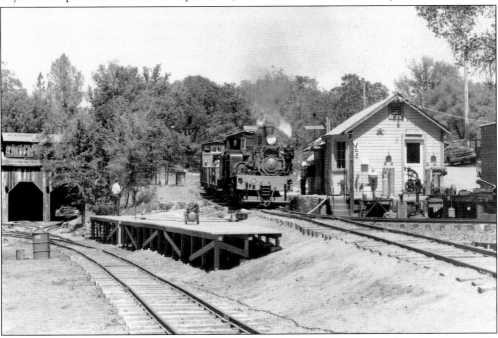

After the narrow gauge Westside logging railroad was converted to a tourist line, the Pacific Locomotive Association sponsored a moonlight ride out to River Bridge for an evening barbeque. After 11 years, Shay-powered log trains once again ran on the Westside as part of the association's 1971 Steam Spectacular. Number 15 is now on the Yosemite Mountain–Sugar Pine RR. (Author's photo.)

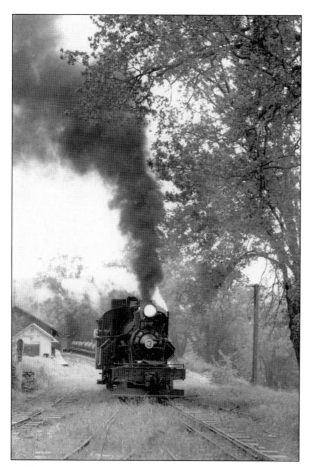

Seeking out California's dwindling number of steam engines, a field trip was made to the Westside Lumber Company at Tuolumne in 1963 for a day of mill walking with standard gauge mill switcher No. 3. Photo run-bys were held throughout the mill, which later closed and burned down during a strike. This engine is now at Roaring Camp. (Author's photo.)

PLA chartered Canada's Prairie Dog Central and polished the rails of Canadian National's branch line to Gran Prairie, Manitoba, with their classic 1875 Scottish-built, coal-burning 4-4-0 and three wooden coaches. The return trip featured a bonus fast run over CN's mainline directly into Winnipeg's modern rail terminal. (Author's photo.)

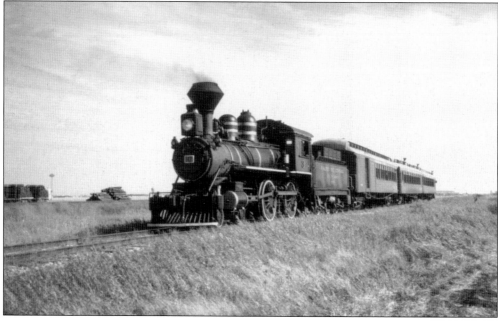

One of the last Southern Pacific passenger trains through the canyon rounds the curve at Estates Crossing, approaching Brightside. Power was provided by Southern Pacific's aging F-units on this February day of 1969. The Pacific Locomotive Association's "Springtime Special" took a popular triangle route—Oakland to Niles, to Sacramento via Stockton, and back to Oakland. (Courtesy of Joe Ward.)

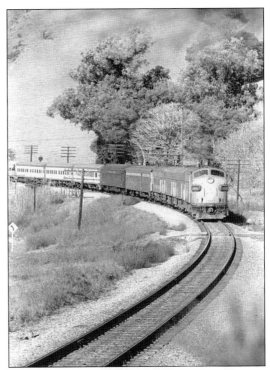

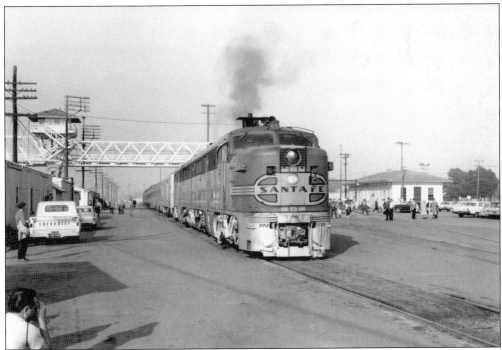

Santa Fe Nos. 67 and 58 depart Richmond March 3, 1968, on the Pacific Locomotive Association's "Last Run of an Alco PA," with a final roundtrip run to Stockton. Requests by the association to have one of these classic passenger units donated for preservation were never answered. Today, only two examples can be found in the United States. (Courtesy of Don Hansen.)

Passing under the Farwell Bridge telltale, the 1967 Springtime Special, with No. 9120 on the head end, marked the one and only time a Krauss-Maffei diesel-hydraulic locomotive powered a passenger train in America. Southern Pacific bought 12 of these German units to see how well they would do under American conditions. They failed, due to the cost of extra maintenance.(Courtesy of Joe Ward.)

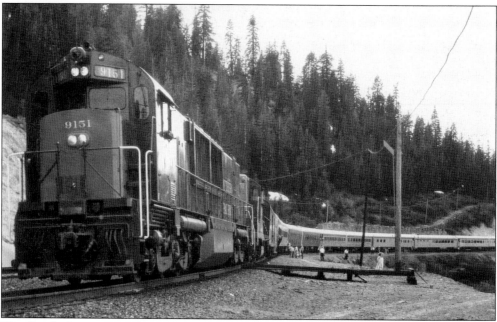

The Pacific Locomotive Association's "Truckee Limited" trains featured freight locomotives enjoying their one day of fame on the head end of a passenger special. America's answer to the Krauss-Maffei was the Alco model C-643, a 4,300-horsepower diesel-hydraulic. On this day, No. 9151 has the honor, including a photo stop at Shed 47 on May 30, 1968. (Courtesy of Dudley Westler.)

Other unusual excursions included a railroad tour of Hawaii, using the SS *Independence*, and a series of deluxe "Remote Canada" rail tours by private train. Pictured here at Hay River on Great Slave Lake, Northwest Territories, is the second passenger train ever to visit this location. Some routes hadn't seen a passenger train in 70 years. (Author's photo.)

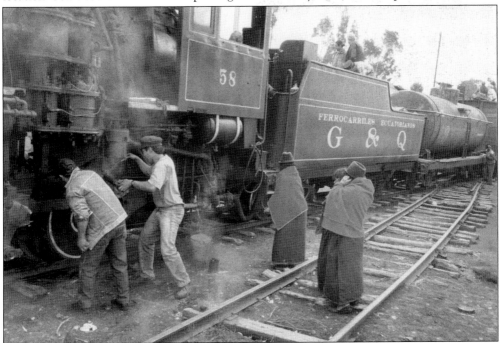

Ecuador's tenacious Guayaquil & Quito, clinging to stay alive as well as to the rock wall of the "Devil's Nose," demonstrated that dedicated workers and a friendly attitude can keep a railroad running in spite of a lack of government funding. Guayaquil & Quito No. 58 on this Pacific Locomotive Association special is the last narrow-gauge steam locomotive built in the United States (Baldwin, 1952). (Author's photo.)

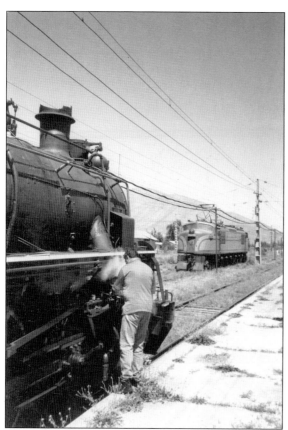

A "Little Joe" type electric has just helped Alco 2-8-2 No. 714 over the mountains between Santiago and Valparaiso, Chile. Some interesting branch lines proved exciting for the Pacific Locomotive Association's special train, with lush foliage covering the track on steep grades and no sand on the steam engine. This trip went as far south as Puerto Montt. (Author's photo.)

In 2001, the Pacific Locomotive Association was allowed to visit Cuba, where a variety of American-built steam engines still ran during the sugar cane harvest. Number 1829 assembles the Pacific Locomotive Association's train. As Cuba's mechanical people talked with the association's mechanical people, information on keeping vintage steam engines running in modern times was exchanged. (Author's photo.)

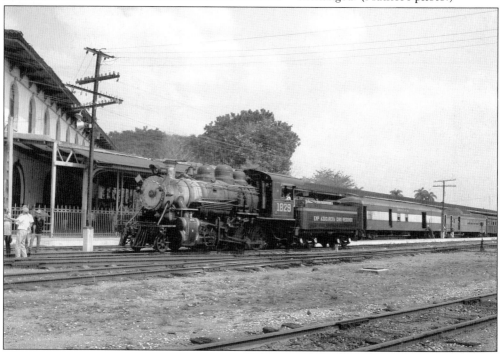

Nine

CASTRO POINT RAILWAY
THE COLLECTION BEGINS

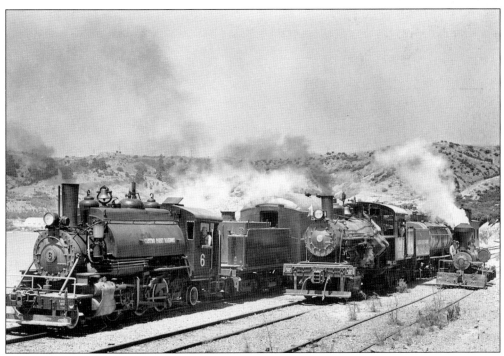

The tradition of multiple engines and trains operating on the Fourth of July holiday began on this day in 1970. It continues to be the day at Niles Canyon when all the improvements and additions of the past year are presented to the members. (Courtesy of Robert Hogan.)

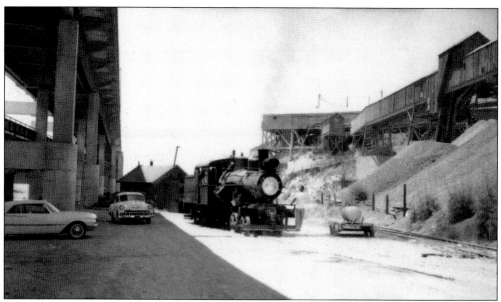

Blake Brothers two-truck Heisler sat unused under the Richmond-San Rafael Bridge for years, until June 16, 1961, when the engine was fired up for the group. An offer to sell the engine for $750 to the group was declined by the founding members, having already spent their life savings on the Howard Terminal engine. (Author's photo.)

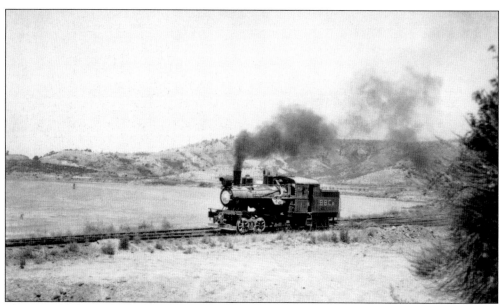

This was the last run of Blake Brothers steam over their railroad. But it was also the group's introduction to a scenic little railroad that ran along the shores of the bay, built as the Castro Point Railway and Terminal Company. In 1967, an agreement with new owner Quarry Products leased the railroad to the Pacific Locomotive Association for the sum of $1 per year. (Author's photo.)

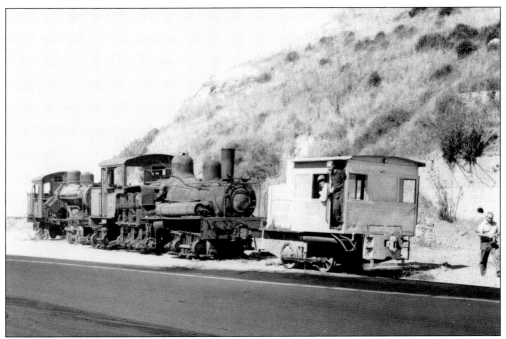

Heisler No. 5 was the first locomotive to arrive at Castro Point, followed by Shay No. 12, both coming from Stockton by truck. Back on rails again, the two were towed into the yard area by Blake Brothers little dinky for heavy repair. Both were destined for Cuba until the sale fell through. The date is October 7, 1967. (Courtesy of Don Hansen.)

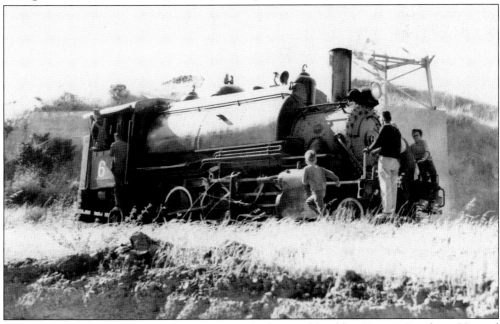

In the late 1930s Sierra Railway No. 30 was rebuilt at Oakland by Western Pacific as Howard Terminal No. 6. Sold to the Pacific Locomotive Association in 1962, No. 6 became the first engine under steam on the Castro Point Railway on May 31, 1969. Engineer Karl Koenig was at the throttle for this event. (Author's photo.)

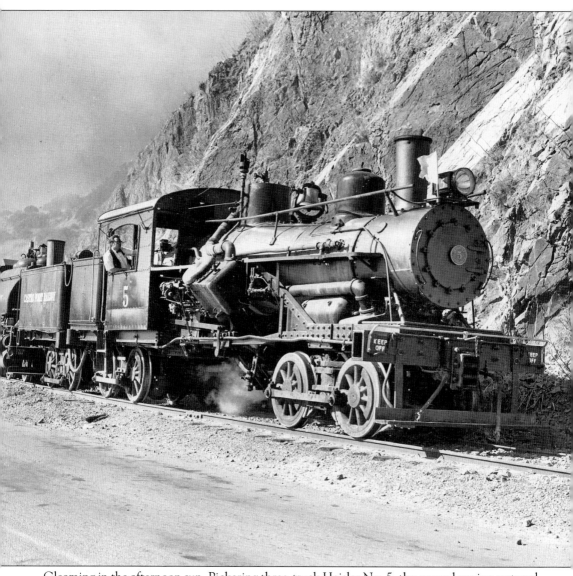

Gleaming in the afternoon sun, Pickering three-truck Heisler No. 5, the second engine restored to running condition, joins No. 6 on a doubleheader in 1973. The locomotives were lettered "Castro Point Railway," which was the original name of this railroad. The Pacific Locomotive Association later changed this policy so that each engine would reflect its own railroad history. (Courtesy of Robert Hogan.)

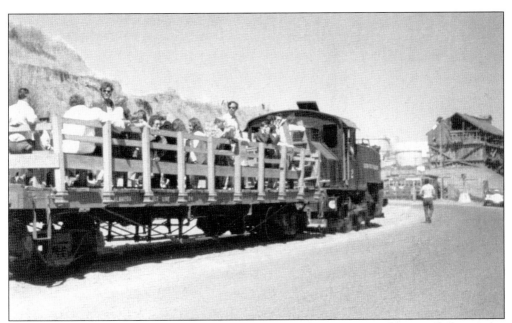

The train was very basic at first, consisting of the steam engine and a wooden flat car fitted with railings and bales of hay for seats. A set of wooden steps at Molate Beach was used for boarding. It wasn't elegant, but it worked. The railroad proved to be popular, and a second open car was soon added to the train. (Courtesy of Warren Benner.)

Master Mechanic Pete Rogers stands in the gangway while Engineer George Childs discusses the unique features of a Heisler locomotive. Both are volunteers, as are all the people who helped make the Castro Point Railway, as well as the Niles Canyon Railway, a genuine sample of California's railroading past. (Courtesy of Robert Hogan.)

Quincy No. 2 was put into service in 1973, hauling passengers. It was a scenic ride along the bay, and free rides were offered on the first Sunday of each month. Some passengers returned to ride every month. Because this was an active, operating museum, membership and the collection of vintage trains grew each year.

In 1978, Mallet No. 4 was the next steam locomotive to operate at Castro Point. As this locomotive is basically two steam engines under one boiler, the forward engine swivels, allowing the locomotive to negotiate sharp curves that made the No. 4 a favorite along the serpentine Castro Point Railway. (Courtesy of Roger Lambert.)

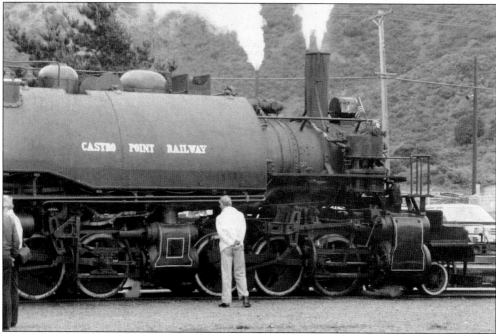

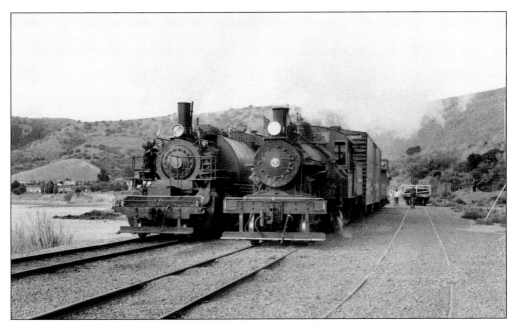

The 2-6-6-2T passes by on the main with a passenger train, while Heisler No. 5 waits in the siding with a freight. This Tank Mallet, where the water tank is carried over the boiler rather than in a tender, is identified by the "T" following the wheel arrangement. There are only two tank mallets currently operating in the United States. (Courtesy of Roger Lambert.)

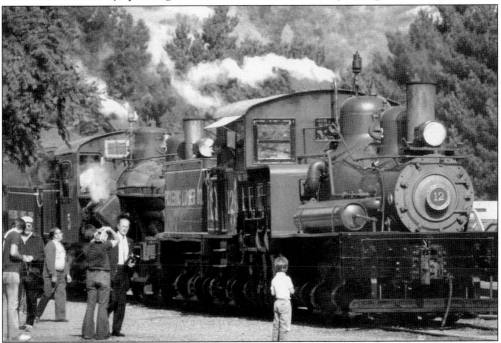

Regardless of a person's age, steam engines are fascinating to watch, each with its own personality. Shay No. 12, built by Lima for Sierra Railway in 1903, is the oldest three-truck Shay in existence. An offset boiler compensates for the three cylinders on the right side. This classic Shay returned to operation in 1984. (Courtesy of Roger Lambert.)

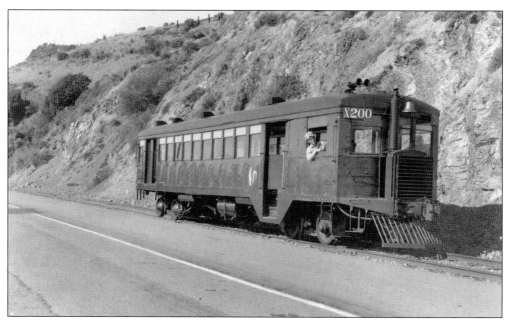

When M200 arrived from the California Western, it received a maroon paint job similar to its original Trona Railroad color. But the little *Skunk* was not painted out, and this led to the car being repainted yellow once again to be historically correct. (Courtesy of PLA collection.)

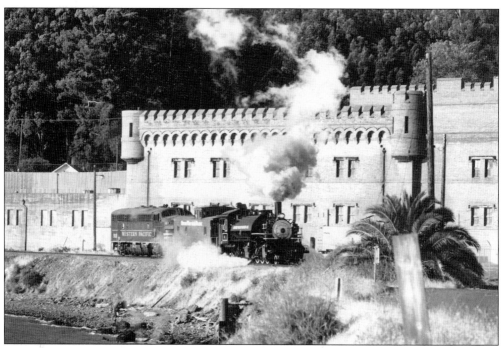

The impressive buildings of Winehaven dwarf the special train coming from the Richmond Belt Railroad interchange. Mallet No. 4, with a caboose for the crew, is bringing in F7A No. 918, which had been recently donated by the Western Pacific, and was in dire need of a major overhaul. (Courtesy of Jim Evans.)

The All Day Lunch Car, once popular on Southern Pacific excursion trains, had six-wheel trucks that wouldn't fit around Castro Point's sharp curves. The car was dropped off at Molate Beach for the day to provide light food service. Manager Carol Sullivan (far left) enjoys a break. The kitchen is located behind the bookshelves. (Courtesy of Rhonda Dijeaux.)

AT&SF sold their 44-ton switcher No. 462 to the Dupont Corporation plant at Pittsburg, CA, who donated it to the Pacific Locomotive Association when it was replaced with a larger diesel. Here the 462 is on a caboose hop with Northwestern Pacific No. 30. The structure ahead of the 462 is the double-deck Richmond-San Rafael Bridge. (Courtesy of Robert Hogan.)

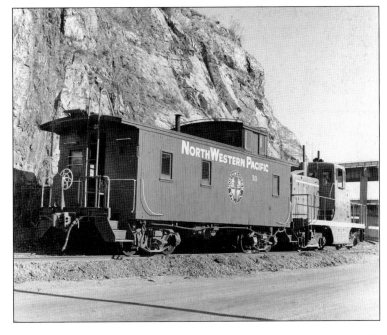

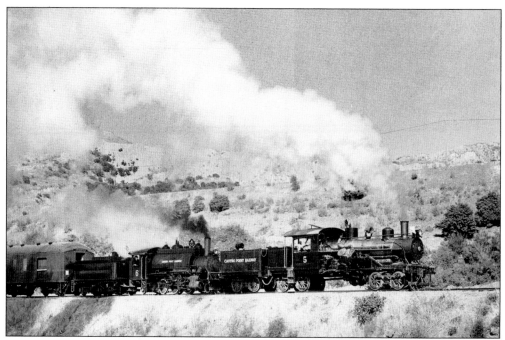

Passengers enjoyed scenic bay views as the train traveled along the shoreline. Time, however, was running out at Castro Point, as the Navy had plans for the property. A move was imminent, but to where? Five locations were considered, with Niles Canyon topping the list. An agreement with Alameda County followed. (Courtesy of Robert Hogan.)

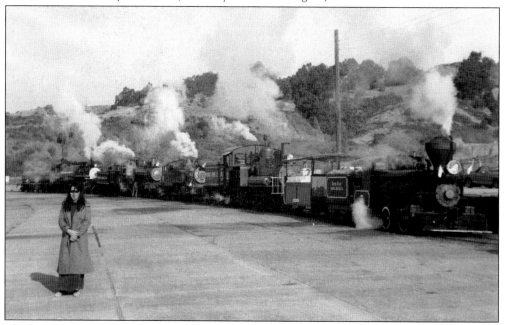

The last big steam-up at Castro Point was on a crisp November 3, 1984 day, when five—count them—five locomotives are under steam. From right to left are 0-4-0 No. 3, Shay No. 12, Quincy 2-6-2T No. 2, Heisler No. 5, and Clover Valley 2-6-6-2T No. 4. All have since been transferred to the Niles Canyon Railway. (Courtesy of Rhonda Dijeaux.)

Ten

SCRAPBOOK

A POTPOURRI

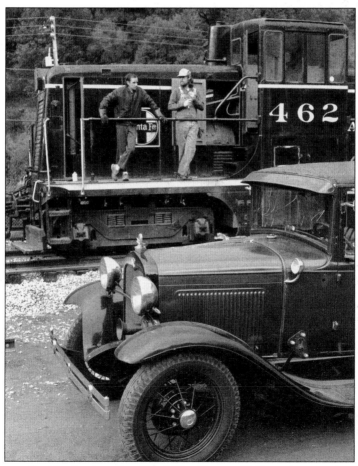

Classic cars go well with classic trains. The Niles Canyon Railway is a popular destination for several vintage automobile groups, including a Stanley Steamer club. Ed Powell (left) and John Follansbee on the No. 462 discuss the difference in horsepower—and fuel mileage—of the car versus the locomotive. (Courtesy of Alan Frank.)

The Southern Pacific removed signals on the Niles Canyon line when the track was taken up. Vintage replacement signals, considered outdated by the railroads (such as this "mechanical flagman" wig-wag being serviced by volunteer Curt Hoppins) make their way to Niles Canyon for preservation as part of the heritage of railroads. (Courtesy of Alan Frank.)

The first of 20 rare Southern Pacific semaphores, rescued as they were being shipping from Arizona to an Oakland scrap dealer, will make an interesting exhibit when they are made operational in the canyon. A number of more modern "target signals," salvaged from SP's Martinez–Tracy line by PLA's electrical department, will also shine again some day. (Author's photo.)

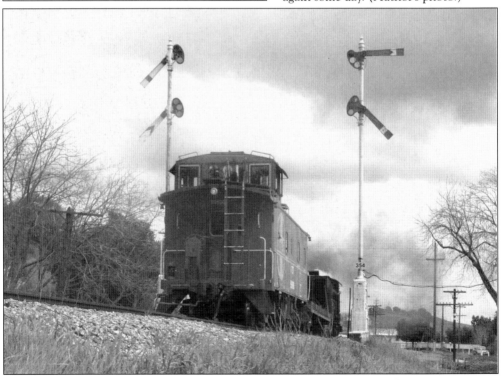

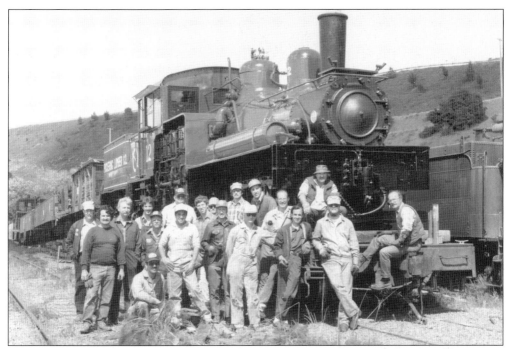

Pickering No. 12 and Quincy No. 2 moved from Castro Point to Niles Canyon via a 2,100-mile visit to Vancouver, British Columbia, where they were invited by Expo '86 to participate in SteamExpo. The "loading crew" has just loaded No. 12 onto a flat car, and it is ready to begin the journey. (Courtesy of Stephen Slabach.)

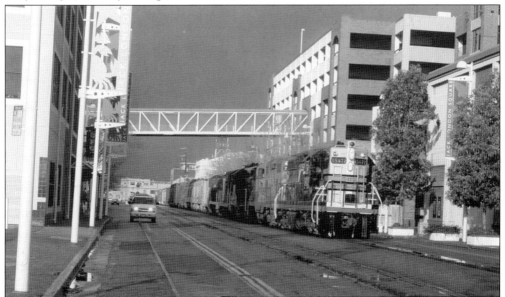

On January 8, 2005, this special Niles Canyon Railway en route to Hearst broke the morning stillness at Jack London Square. Trailing behind Southern Pacific SD-9 No. 5472 and GP-7 No. 5623 (with Engineer Lou Bradas at the controls) are a variety of locomotives and cars that were storaged at Oakland. Three steam engines at Fremont were also collected. After 20 years, the move from Castro Point to Niles Canyon was complete. (Author's photo.)

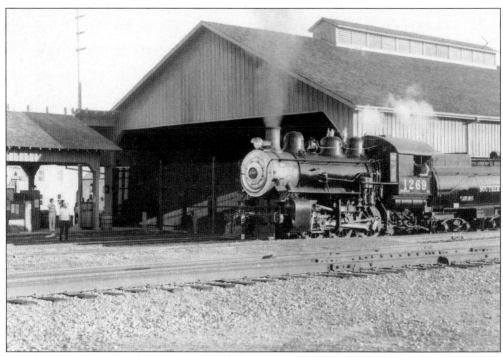

Another traveler is Southern Pacific 1269, showing off at Railfair '91. The 0-6-0 stayed in Sacramento after the fair closed to work on the state museum's Sacramento Southern Railroad for a couple of seasons before arriving at Brightside. (Author's photo.)

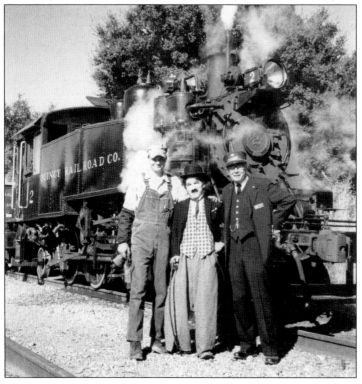

To celebrate the long-gone days of moviemaking, Niles' annual silent movie festival brings to life the Little Tramp and his memorable antics in Niles Canyon. Here "Charlie" graciously poses with Engineer Jeff Schwab and Conductor Al Harvey after flagging down the train for a ride back to Niles. (Author's photo.)

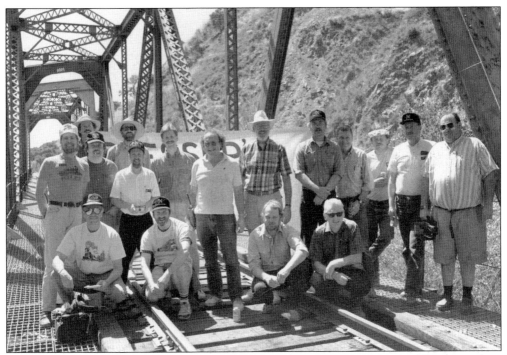

The track crew poses on Dresser Bridge at the grand reopening ceremony. All are members of the nonprofit Pacific Locomotive Association, donating their time and talent to keep the museum trains running on the all-volunteer Niles Canyon Railway. A barbeque for the 200-plus attendees followed. (Courtesy of Alan Frank.)

Niles Canyon Railway's Commissary Department provides food and beverages for various occasions. Connie Luna serves snacks in the 1911-built Southern Pacific coach. A barbeque in the Depot Gardens at Sunol, or a dinner featuring railroad cuisine in the elegantly restored 1927 Southern Pacific dining car, are also popular. (Courtesy of Alan Frank.)

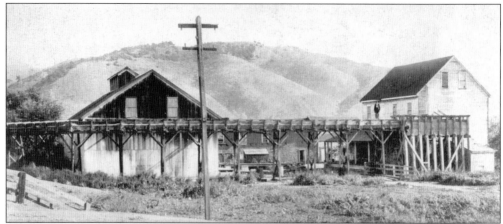

In 1841, Jose de Jesus Vallejo, brother of General Mariano Vallejo, the first governor of Alta California, built a flour mill on his *Rancho Arroyo de la Alameda* near what is now Mission Boulevard. The mill was powered a 20-foot water wheel, supplied from a two-mile-long flume that originated in the canyon. It closed in 1884. (Dr. Robert Fisher Collection; courtesy of Museum of Local History, Fremont.)

Another famous celebrity put Sunol in the national spotlight when its citizens gave a majority of their mayoral votes to a Labrador mix. Four-legged Mayor Bosco beat out his human competition for this honorary position. Shown here in his first pet parade at the Sunol Glen School, Bosco turns on the charm.

This fuzzy picture, taken in the 1880s, is of the Rankin Adobe, located near the mouth of Niles Canyon. In the early 1850s, this was the home of the notorious, poetry-reading bandit, Joaquin Murrieta, one of the famous characters of Niles Canyon.

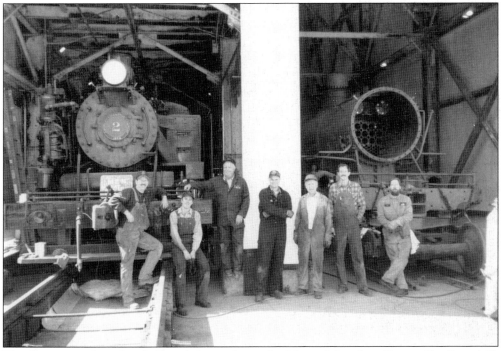

The shop crew takes a break. From left to right are Joe Mann, Johnathon Kruger, Ken Brunskill, Jeff Schwab, Chris Holombo, Alan Siegwarth, and Tim McNeil.

With the kerosene marker lights glowing on the rear end, a Sunday train leaves Niles behind and heads toward Sunol on a leisurely trip through Niles Canyon. This photo could have been taken 80 years ago, but the pleasing experience of an actual ride on the *Transcontinental* is still here, available to everyone, on a living museum known as the Niles Canyon Railway. (Author's photo.)